IMAGES
of America

AFRICAN AMERICANS
OF SPOTSYLVANIA
COUNTY

ON THE COVER: One of the most demanding yet revered teachers was Thelma Pryor, who insisted on maintaining high academic standards. She preferred teaching elementary children in order to start them out well. The grading scale began at 100 points for an A+ and progressed downward to 75 points for a D-. Failure began at 74 points and was simply not an option. (Courtesy Thelma Robinson Pryor estate.)

IMAGES
of America

AFRICAN AMERICANS
OF SPOTSYLVANIA
COUNTY

Terry Miller and Roger Braxton

ARCADIA
PUBLISHING

Published by Arcadia Publishing
Charleston, South Carolina

Printed in the United States of America

Library of Congress Catalog Card Number: 2007937954

For all general information contact Arcadia Publishing at:
Telephone 843-853-2070
Fax 843-853-0044
E-mail sales@arcadiapublishing.com
For customer service and orders:
Toll-Free 1-888-313-2665

Visit us on the Internet at www.arcadiapublishing.com

To the spirit of Hannah Hicks, a 100-year-old black woman who reportedly was the oldest person alive in 1870 Spotsylvania.

CONTENTS

ACKNOWLEDGMENTS

We first thank the professionals at Arcadia Publishing and especially our editor, Brooksi Hudson. Ritz Camera in Central Park and Tri-City Photography in Chesapeake, Virginia, were masterful at repairing some of the photographs. We give them our sincere thanks.

While everyone was terrific in sharing their stories and images, special thanks go to the following: Anita Roberson, Lillian Hart Brooks, Clinton Braxton Jr., Alberta Robinson, Lillian Pryde, Bea Smith, Dorothy Smith Moore, Barbara Lewis, Ida Lewis, Leon and Lula Lewis, Doris Barnett, Cynthia Hill, Booker T. Ross, and Richard McCall.

For their invaluable assistance in navigating Spotsylvania's many documents, we thank the Records Room personnel at the courthouse. Gwendolyn Jones gave special help when brick walls were looming.

Many new friends were made and old friendships were strengthened. Particular thanks go to Alison Pryor, Jeanette White, E. Jean Lewis, Shirley Robinson, Julia Fauntleroy, Sam Braxton, Frank Dyson, and James Dyson.

Pastors of the 12 churches that comprise the Sunday School Union showed their appreciation for our efforts in many ways, and we are grateful. Extraordinary historian Cleo Coleman was the first to provide us a forum. To her, we owe a debt that can hardly be repaid. There are simply no others like Rosemary McKinney, Peggy Tyler, and Constance Braxton. Thank you for everything you did to help with this monumental task.

From Roger: I am especially grateful to my children, Shaun and Christy, and my extended family, who continually encouraged and inspired me to stay the course in assembling this great legacy. Equally important is Valery Jones, who shares my life and knows my passion for getting involved with important things. I thank her in ways that only the two of us understand.

From Terry: Flora Richardson gave me a wonderful place to live, made me laugh hard and often, and offered encouragement when I needed it most. My family in Texas reminded me how much I miss them and count on them to keep me grounded. Last, my daughter Pia forever gives me inspiration, and my love, Robert, gives me space. My thanks are deep and abiding for Robert's patience over the many nights I was away from home.

INTRODUCTION

I don't really want to focus on the past. That was such a long time ago and they're dead and gone.

These callous words, spoken in an interview by a Spotsylvania native, made us cringe. We imagined that person's grandparents sitting on their front porch, looking out over the land they had bought with the $1.50 a month they earned working as a field hand for someone who thought so little of them. We thought about the hours of using a washboard to clean somebody else's shirts and the labor of starching, crisply ironing, and precisely folding basket loads of them to be delivered to white men and women up and down dirt roads. And what about the baskets that were handmade from oak trees by strong, rough hands? That statement steeled our resolve because even a casual glance at the landscape of Spotsylvania shows the depth and breadth of an African American struggle and triumph.

In 1870, at the time of the first census count, 153 African Americans aged 70 and older were living in Spotsylvania. Those 153 souls are the ancestors of almost every black person living in Spotsylvania. Our goal is to honor them.

We first apologize because there was so much wonderful information that could not be included in this short volume. There are families with which we did not get to spend time, and we humbly ask for their understanding and forgiveness. Preparing a book like this requires two-way interaction because the writers are asking to step into others' worlds and memories that may be too precious to share at the time. We also worked to verify all information contained in each short caption. Any errors are unintentional.

It is time to take the journey. Chapter one, "In Our Spirits," outlines the history of the 12 founding churches of the Sunday School Union and the key people or events that shaped their formation. Chapter two, "With Our Hands," discusses the different jobs performed to earn the money that paid for land, bought feed bags that were later used to make clothes, and kept food on the table. Chapter three, "In Our Service," provides a brief look at the key organizations formed to help people navigate the difficult world in which they lived. Ancestors realized that working alone produced little benefits, but combining their efforts brought rewards. Chapter four, "With Our Minds," touches upon education, and chapter five, "In Our Arms," takes a nostalgic look at special people and items that are held deeply within the hearts and memories of today's generation. We end with an epilogue in the words of six seniors we met along the way. As we began with an understanding of seniors in 1870, we end with the wisdom that only they can provide right now.

Recognizing that there was so much more to be learned, so many more images to be collected, and so many more questions to be asked, we dedicated each chapter to one or several people who were missed in photographs or conversation. No one should be forgotten.

—Terry Miller and Roger Braxton

One

In Our Spirits

The black rural church has advanced strongly since slaves sat in the balcony of their masters' and mistresses' churches listening to white ministers tell them to obey so they could get their reward in heaven. Whether begun by a gift or purchase of land, a meeting under a tree or brush arbor, or a spot in someone's home on a dirt or plank floor, black churches in Spotsylvania formed from a desire to gather and worship in ways that were familiar to African Americans rather than imposed upon them by majority culture.

Little Mine Road and Mount Zion Baptist Churches were organized before the Civil War. Others began after the war, when people could organize nearer to their homes rather than walking or riding a horse and buggy for many miles.

Where there was a church, there was a "preacha' man." Sometimes called a "chair backer" because that is where he stood, he may not have known how to read, but his fire of words moved others to listen. Because their numbers were few, ministers were on a circuit where they traveled to a different church each week. Preachers needed help, so other men stepped forth as deacons and trustees to pray over the sick, look after widows and the welfare of their children, and spread the word that church meetings were happening on neighboring farms. Even though no hymn books or Bibles were present, they somehow made it work.

Some ministers came from within congregations. People knew them as children, saw them grow, heard them pray, and watched them mature into men of stature and moral authority within the community. "Here come da' ol' preacha' man" was the cry that brought attention to many households as ministers walked the roads to visit folks. Money was scarce, but produce was its own currency; preachers were often paid from the land in addition to their $10 average weekly salary. Walker Howard and James Robinson were two of the earliest ministers who both organized and led churches. It is to their memories that this chapter is dedicated.

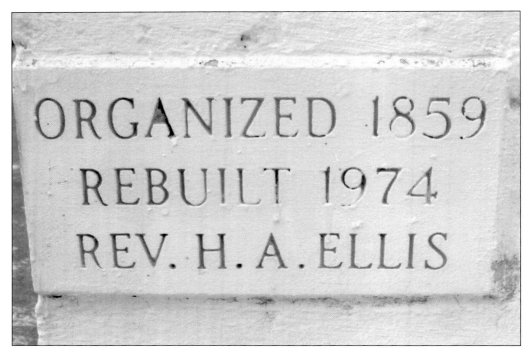

During slavery, one of the black coachmen for a white member of Mine Road Baptist Church took the bold step of asking permission for the black members to start a church of their own rather than continuing to sit in the balcony. Permission was granted. The black congregants left, chose the name Little Mine Road Baptist Church, and reportedly began worshipping in a tent. In 1877, they bought land from black farmers Reuben and Lucy Johnson and later built a permanent structure. The original steps have been memorialized. (Photographs by Terry Miller, April 2007.)

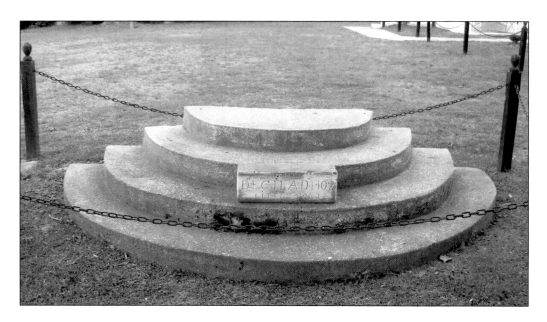

A benefactor of Little Mine Road Church, Julian Terrell was born to Sally Talley about 1863. He married Sarah King in 1882, and the couple had 12 known children. Terrell worked his entire life on the Oakley Farm and bought his first 15 acres in 1883. He amassed nearly 100 acres from which he supported his family and his church. He died in 1919 at the age of 56. (Courtesy Brenda Terrell.)

Next to the location of the original Little Mine Road Church and the memorialized stone steps, a new building was constructed from 1968 to 1974 under the leadership of Rev. Herman Ellis. Crowning the tin steeple and naming the church is an "L." Even if other homes in the area were low on water, the church's well never went dry. (Photograph by Terry Miller, May 2007.)

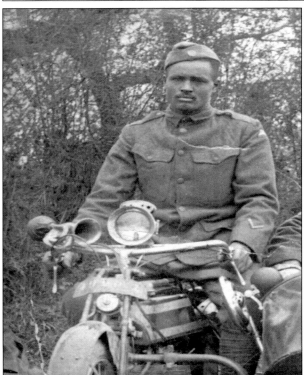

Original members Henry and Louise Beasley told their son Harrison (left) about Mount Zion's history. It was established in 1862 when slaves found a way to worship in the midst of trees. Its first pastor was Reverend Thompson. When the Civil War ended, the congregants constructed a log building where they worshiped until they outgrew that space. Under the new pastorate of David Washington, they bought one acre directly across the road and began digging a basement. James Robinson then became pastor. As it was the only black church for miles, members who could not get there easily began to consider planting churches of their own, and Reverend Robinson encouraged them. (Above original sketch of Mount Zion log church by Thomas Woodward, courtesy Fannie Beazley Woodward; below courtesy Fannie Beazley Woodward.)

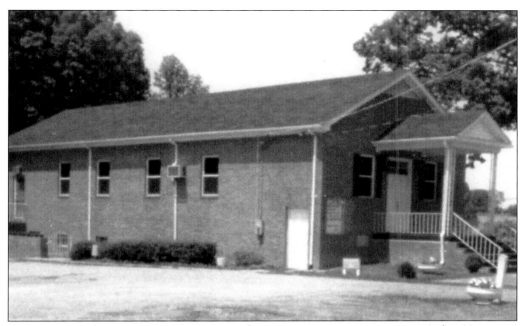

Each minister who came to Mount Zion sought to renovate or construct anew. In his 22 years as pastor, J. M. Boswell (1920–1942) had the first frame church built. Between 1943 and 1974, three ministers presided over the building of a basement, and finally an upper sanctuary was completed. (Courtesy Vivian L. W. Brooks.)

Former slaves at Liberty Baptist in Caroline outnumbered white congregants, and in June 1865, they planted a church and named it Bethlehem Baptist. By 1921, they owned five acres and a church insured for $3,600. The federal government forced the congregation and many others to sell and immediately vacate 70,000 acres by May 31, 1941, so a World War II training camp, A. P. Hill, could be constructed. Some relocated to Spotsylvania and rebuilt their church. (Photograph by Terry Miller, May 2007.)

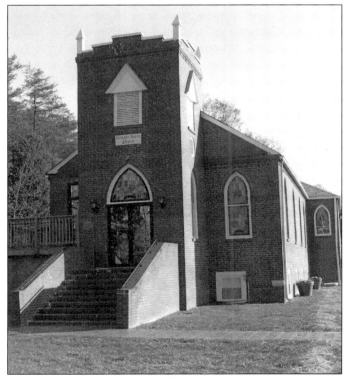

13

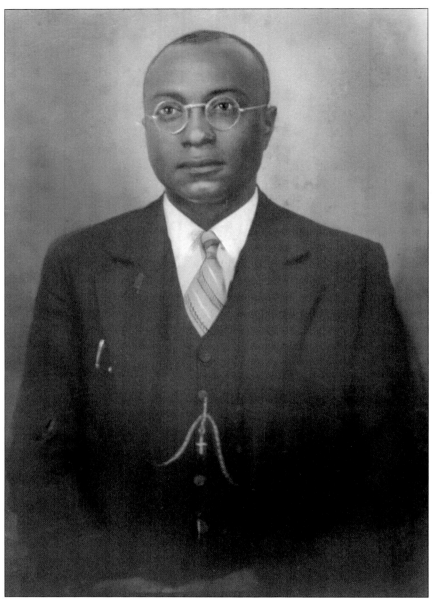

Known as "Haskey," Rev. Samuel H. Carter (born in 1907) became pastor of Bethlehem Baptist Church, along with Zion Grove in nearby Caroline County, in 1942. He also accepted two additional pastorates at Mount Tabor Baptist Church in Shumansville and First Baptist Church in Guinea. The son of George and Sallie Reynolds Carter, he worked in a Maryland steel mill and sent money home to the family. He answered the call to preach, finished his schooling, received his license in 1932, and was ordained in 1937 at Union Baptist Church in Sparrows Point, where he then served for seven years as assistant pastor under the dynamic Rev. Chinor H. Coleman. Reverend Carter believed so strongly in his mission that in his big, booming voice he said, "I'll preach if you pay me and I'll preach if you don't." And his preaching was mighty. "You've got to give them that or they won't come back," he said to his Methodist-raised wife, Ruth. "You can tell them Carter said it." (Courtesy Samuel H. Carter Jr.)

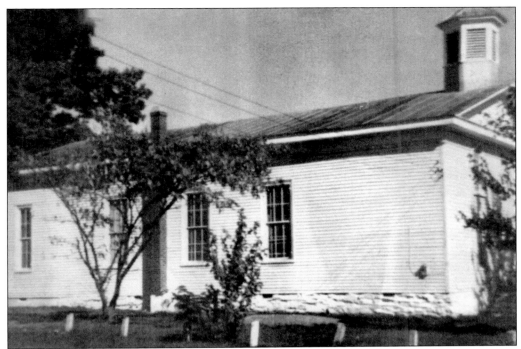

Itinerant preacher William Hoe established Branch Fork Baptist Church near Holladay's Mill between 1866 and 1868. After 15 years, Jesse H. Stubbs Sr. sold the membership one acre for $15. Land boundaries established in the original purchase proved inaccurate, and a new survey was commissioned. Witnesses to the accuracy on March 21, 1910, were Lewis Terrell, Joseph Woolfolk, Preston Despot, Henry Coleman, and J. F. Stubbs. (Courtesy Branch Fork Baptist Church archives.)

Patrick Graves (c. 1835–1913) led the congregation through its growth years. He was born on the Waddy farm in Louisa County to Patrick Sr. and Caroline Graves. This farmer-turned-preacher walked and rode a mule to talk to black folks about organizing churches. He was in demand for his courage as well as his preaching, banjo playing, and singing. Married to Susan Coleman, he fathered 10 children. (Courtesy Branch Fork Baptist Church archives.)

Fennell Festus Terrell became the second of 19 children born to Lewis and Rosa Spencer Terrell on July 14, 1885. He stopped his one-room schooling at age 11 when he was sent to the nearby white Powell farm, where he slept on a dirt floor and worked from 4:00 a.m. to sunset and earned only $1.50 monthly. In 1908, he bought 61 acres from his parents and tried his hand at farming. Looking for better work opportunities, he moved to Elmyra, New York, and then to Philadelphia. Accepting the call to ministry in 1922, Terrell soon married the Tennessee-born Annie Bell Manuel (shown below with her daughter Deborah. They started their family and eventually moved back to Spotsylvania. He died on April 13, 1980, at age 94. (Courtesy Deborah Terrell Smith.)

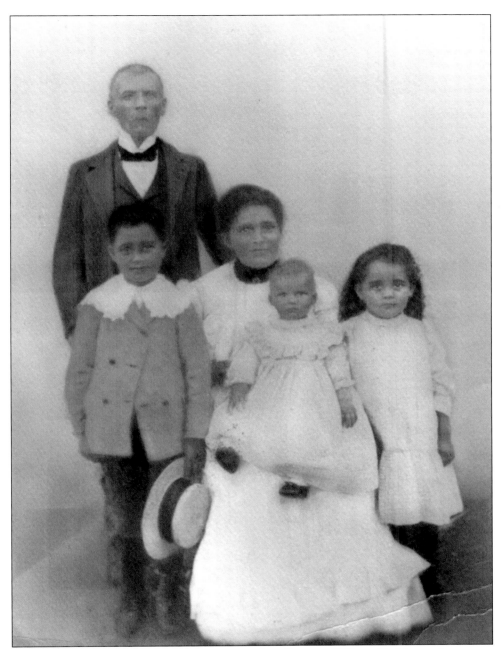

We never know from what beginnings great people will come. William Stubbs was born around 1841 to Jesse Sr. and Sarah Stubbs. He first married Martha Clarke and had six children (five girls and one son, Hayes). After Martha's death, in 1891, he married Marcia, shown about 1906 with three of their children: John, Lannie, and baby Alice. William died soon after this photograph was taken, and his son John took on the role of provider. William's older son, Hayes, became the provider for the first family. Using their inheritances, John and Hayes eventually became two of the most influential men in the life of Branch Fork Baptist Church. (Courtesy Mary E. Stubbs Richardson.)

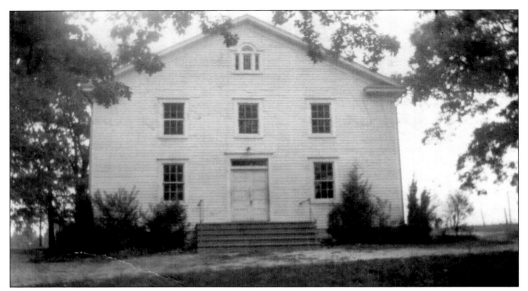

In chilly weather in 1867, people met in the homes of Saul Carter, Rena Tyler, Warner Carter, and Daniel Holmes. In warm weather, they gathered in a brush arbor, and on October 4, 1873, congregants bought land from the Sylvus family, named their church Sylvania (later changed to Sylvannah), and, over time, built a frame structure. The church's members lived in the county's commerce and government section and therefore had more access to opportunities that fueled more material gains than other areas. (Courtesy Peggy Tyler.)

Edele, also known as "Edith" and "Eda," was born to Daniel and Martha Lewis Holmes around 1849. Her father and one of her younger brothers, Oscar, were shoemakers. Her other known sister and brother were Caroline (married to Henry Samuels) and Moses. Edele grew up in a home where early Sylvannah members met during the church's formative years. She wed Warner Carter in 1868 and gave birth to 11 children. (Courtesy Constance Braxton.)

Born around 1877 to Delphia Coleman, Chinor Coleman accepted the call to preach and quickly developed a reputation as a fire-and-brimstone minister who put fear in the hearts of children. One of the most popular preachers in Spotsylvania, he not only served Sylvannah from 1908 to 1925, but from 1913 to 1933, he pastored at Branch Fork while also leading Piney Branch and First New Hope. In addition, he was a frequent preacher at Beulah Baptist. Coleman married Maggie Washington in 1898, and the couple had one child: Atlanta Grace. Maggie died in the early 1920s, and by 1923, Coleman had married Gertrude Elaine Guss. The couple had two children: Gwendolyn Elaine and Chinor Jr. Always the natty dresser, one year he asked his Piney Branch congregation for black silk rather than cotton socks for Christmas. "Buy them yourself" was the response. Having been in almost every pulpit and part of every association in Spotsylvania and neighboring counties, he relocated to Sparrows Point, Maryland, in 1933 to take the pastorate at Union Baptist Church, where he remained until his death on January 31, 1950. (Courtesy Sylvannah Baptist Church archives.)

Rev. Leroy Emanuel Bray Sr. pastored at Sylvannah for 31 years (1947–1978) while leading two additional churches in neighboring counties. He was known for his ability to understand people, innate leadership abilities, fiscal thrift, lyrical voice, and willingness to use his exceptional electrician's talents during the church's renovation to save money. Born in Hanover County in 1915 to Isaac and Elizabeth Bray, he married Louise Dandridge, and they had five children. (Courtesy Rosemary Quarles McKinney.)

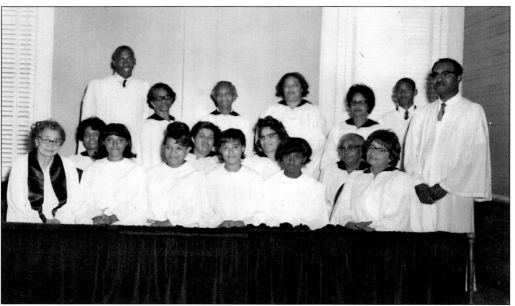

Members of Sylvannah's combined choir included the following, from left to right: (first row) Sadie Combs Johnson, Evelyn Fairchild, Jane Fairchild, Martha Ferguson, Dorothy Baylor, Ruth Taylor, Beulah Fairchild, E. Jean Lewis, Sadie Fairchild Coleman, and Pearl Flippo; (second row) Jim White, Elizabeth Dixon, Lena Sample, Bertha Fairchild, Essie Lewis, Layton Fairchild Jr., and Rev. L. M. Bray. (Courtesy Jeanette Lewis White.)

All but three of the original black churches in the county have a cemetery on their grounds. The first grave at Sylvannah, in 1946, and every grave since has been dug and/or supervised by Alfred "Dadie" Fairchild (born in 1918). The arch entrance was donated by Inez Bacoats, and the brick wall was designed, constructed, and donated by Alfred's younger brother Layton Sr. in memory of their parents, Alfred and Rosa Lewis Fairchild. (Photograph by Terry Miller, April 2007.)

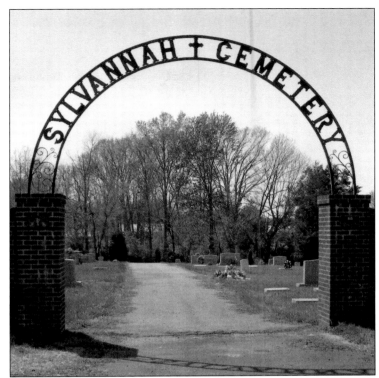

Established in 1868, primarily by members of the Cole and Wigglesworth families, Mount Olive Baptist Church was first positioned so that the water pump was in the rear. When the need for church expansion became apparent, the structure was physically turned to face another side so that there would be enough space to build. (Photograph by Terry Miller, July 2007.)

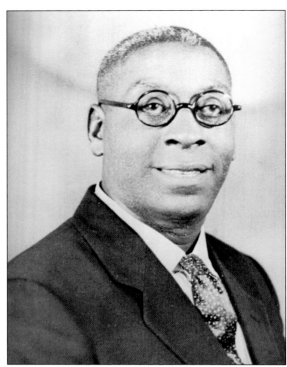

Like many preachers of the early 1900s, Oliver S. Robinson traveled across county borders to pastor more than one church. Born in Louisa County to James and Mary Robinson about 1887, he served Mount Olive and Branch Fork and died on February 14, 1955. (Courtesy Rev. Dr. Ronald C. Williams and Mount Olive Baptist Church archives.)

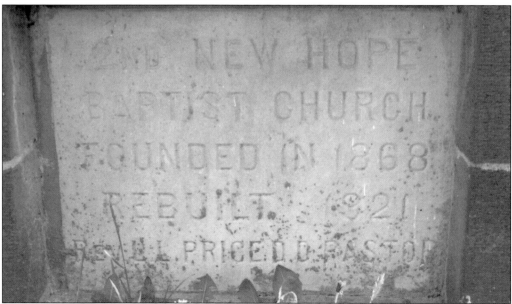

In 1868, black congregants were separated from the white Massaponax Baptist Church. They walked several miles down the road, named their entity Second New Hope Baptist Church, and worshipped in an old log schoolhouse. They bought land on June 23, 1883, from Richard and Elizabeth White and built their church under the leadership of York Johnson. In 1891, a faction left and formed a new church nearby, New Ark Baptist, also known as Newark. (Photograph by Terry Miller, May 2007.)

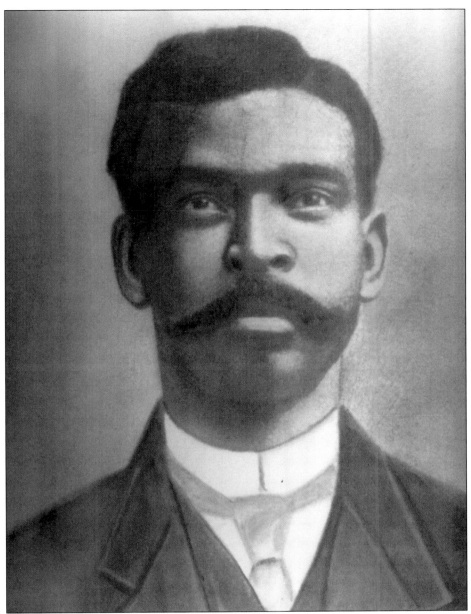

With 23 years of leadership, Lloyd L. Price (born in 1869) was the longest-serving pastor of Second New Hope. He arrived in 1920 after church turmoil and five pastors and began the church's rebuilding by working tirelessly to reunite it with members of New Ark. In short order, he was successful. Though Virginia natives, Reverend Price and his wife, Janie, lived in Baltimore and commuted as best they could to the church weekly. Church members so responded to Price's strong, compassionate, and visionary leadership that they began an automobile rally to raise enough money to buy him a car. One member, Mazora Willis, sold her cow and contributed the entire proceeds. He repaid them with kindness and hard work. It was under his pastorate that the current church building was constructed. Reverend Price died in 1943 at the age of 74. (Courtesy Second New Hope Baptist Church archives.)

Like nothing Second New Hope had ever seen, a homegrown minister was called to be its pastor in 1947. He was already serving as pastor of his home church, Piney Branch, at which he remained until 1950. Born in Spotsylvania in 1917, Rev. Russell Robinson was the son of James Henry Sr. and Clara Brooks Robinson and the grandson of Rev. James Allen and Ella Slaughter Robinson. He was baptized at Piney Branch at age 10 by Rev. Chinor H. Coleman. To prepare for the ministry, Robinson attended both Virginia Union (1941) and the Washington Baptist Seminary (1943), after which he was ordained and began pastoring. On August 8, 1941, he married Delma Comfort, the daughter of Preston and Gertrude Comfort and granddaughter of Wilson and Garnet Acors Comfort. Russell and Delma had two children. In January 1967, after almost 20 years at Second New Hope, he died at the age of 49. Robinson's son Wayne is now carrying on the family ministerial tradition at Bethlehem Baptist Church. (Courtesy Thelma Robinson Pryor estate.)

Special because it was not derived from a white church, First New Hope Baptist Church (established in 1871) came from people wanting a place to worship after listening to sermons from traveling minister Patrick Graves. After three years of praising on the farms of Gabriel Boggs, W. L. Day, and William Williams, where baptisms were also held, 15 folks met in the home of Fleming and Alsie Ellis (pictured) on the former Elim plantation and organized a church. (Courtesy Shirley Robinson.)

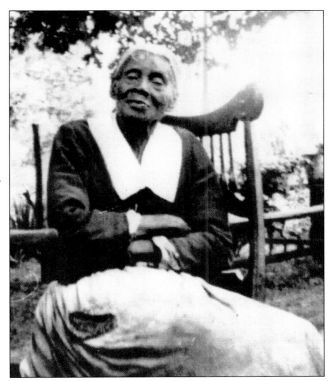

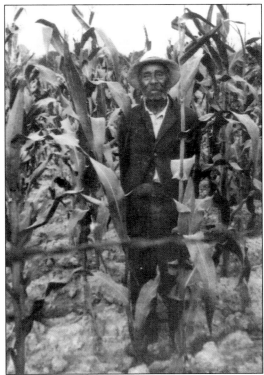

The principal organizer of First New Hope was former slave and blacksmith Richard Moss Sr. (born around 1819). He, his wife, Maria Robinson Moss (a former slave on the Lewis Boggs plantation), and his children all moved from the white Elk Creek Baptist Church in Louisa to Spotsylvania. His son, Richard Jr. (1850–1937), shown here, farmed his entire life and left his ancestral land to be passed down only to his heirs—never to be sold. (Courtesy Jean Moss.)

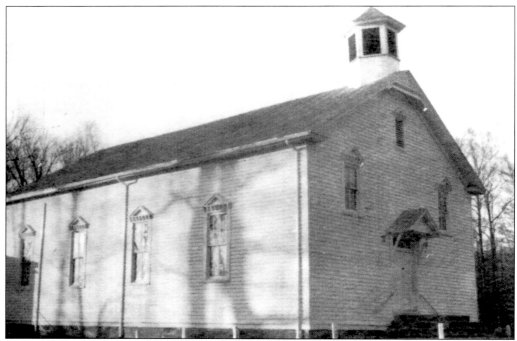

First New Hope's original building was erected on one acre the congregants purchased for $5 from William and Lucy Williams. They chose Patrick Graves as pastor. Worship services were on the first and third Sundays, as Reverend Graves traveled miles to minister to Branch Fork Baptist Church on the second and fourth Sundays. (Courtesy 108th anniversary booklet, loaned by Sylvia Taylor Boone.)

Please help us in our Queens Rally for the benefit of painting the interior of the

First New Hope Baptist Church

Spotsylvania County, Va.

..Solicitor

Rev. C. H. Coleman, D. D., Pastor

A few years after the death of Patrick Graves, the congregation chose the charismatic Chinor H. Coleman as its third pastor. Already pastoring at Sylvannah, Reverend Coleman accepted the additional role from 1918 until 1935, when he resigned to take a position at Union Baptist Church in Maryland. While at First New Hope, he was a tireless fund-raiser. (Courtesy Rev. Gilbert Garcia and First New Hope Baptist Church archives.)

Born in Caroline County to Claybourne and Martha Guss about 1894, Eldoras R. Guss worked as a preacher and then pastor in Spotsylvania. In 1935, he became the fifth pastor of First New Hope Baptist Church, serving that congregation until 1956. (Courtesy Rev. Gilbert Garcia and First New Hope Baptist Church archives.)

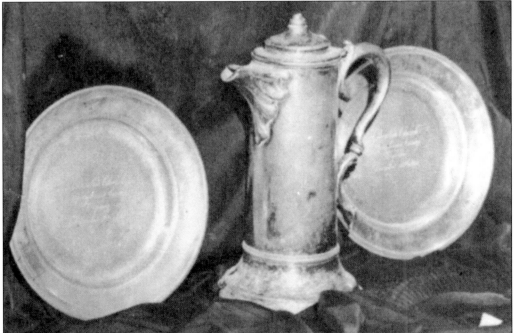

Beulah, an outgrowth of the white Bethany Baptist, began with 30 members in 1872. The group purchased land from Charles Beasley and made a temporary worship center, choosing the name Beula (later Beulah) Colored Baptist Church. The first moderator was James Wright, and the clerk was Cyrus C. Coleman. One of the members of Bethany gifted the growing congregation its first communion set at Christmas in 1880. (Courtesy 100th anniversary booklet.)

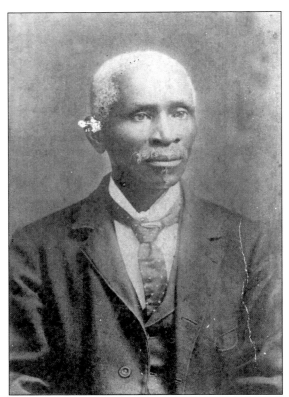

A founding member of Beulah was James Minor Sr. (1847–1915), the son of Charles and Lucy Minor. On the second Saturday in July 1872, he was asked to preach until the congregation could procure a permanent pastor. In a March 1874 meeting, Minor was licensed and remained the de facto pastor until his death in 1915. He first married Sheba Conway but was a widower by 1900. He then wed Mary Eliza Woolfolk, the daughter of William and Milly Woolfolk, on April 18, 1901. (Courtesy Gladys Rock.)

Trustees Theodore Thornton, James Jackson, and T. H. Reynolds represented Beulah in court in October 1901, asking permission to borrow $300 to finish building their church. Their request was granted by circuit court judge J. E. Mason. The simple frame structure lasted until renovations in 1926. Under the leadership of Rev. C. A. Lindsey (1916–1950), the church was ready for use by Thanksgiving 1932. (Photograph by Terry Miller, June 2007.)

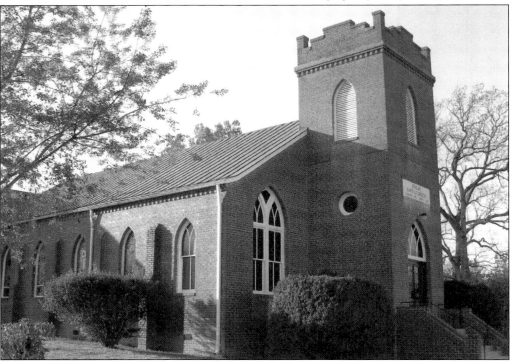

Lydia B. Coleman (1856–1923) remembered the day soldiers from the Union army arrived at the Goodloe farm. They slaughtered and cooked some cattle, and a soldier held her between his knees and fed her. Later she paid $32 to Charles Beasley for the four-acre plot where she raised her family and worked as Beulah's sexton. After Lydia's death, her youngest daughter, Dora Coleman Johnson, donated part of her land to the church. (Courtesy Gladys Rock.)

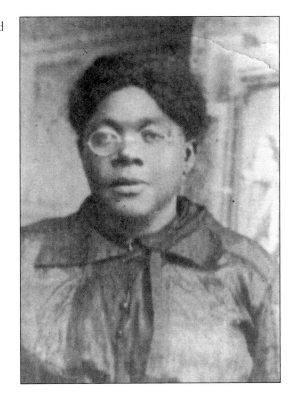

Since 1768, this site has a history of use for Episcopal worship and a Civil War hospital. Organized as Piney Branch Baptist Church in 1872 by Rev. Walker Howard, congregants saved enough to buy two acres and build a log structure, followed soon after by a frame one. The original steps of the frame building have been preserved next to the current house of worship. (Photograph by Terry Miller, April 2007.)

29

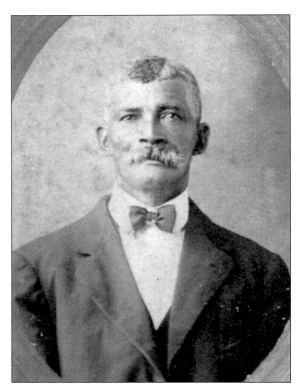

Early Piney Branch member Charles Hughlett (also Hewlet) was born around 1847. He sought permission to marry a woman named Hester who worked on the nearby Aldridge farm. On December 12, 1873, this note was placed in the official record: "This is to certify that Claiborne and Mary Lewis is [sic] willing for Charles Hewlet to marry Hester age about 22 years." (Courtesy Doris Hughlett Barnett.)

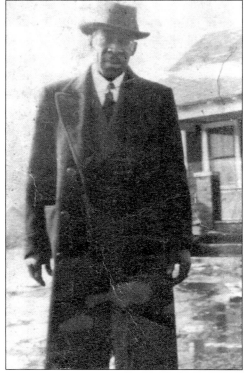

Harry J. Ellis was born in 1892 to Rev. Charles and Fannie Stanard Ellis. He met and married young Louise Jones and, while fathering nine children, pastored four churches simultaneously: Piney Branch on the first Sunday, Mount Oni in Caroline on the second, Sylvannah on the third, and Zion Hill on the fourth. Ellis preached his last sermon at Mount Oni on a Sunday in January 1943. He died the following day. (Courtesy Edith Ellis Fairchild.)

An outgrowth of the white Wilderness Baptist Church in 1880 and distinguished by its twin steeples, Zion Hill Baptist Church originally stood across the road from its current site. For $4.12 on April 10, 1897, William H. Cook Jr. sold the church leadership one acre on which to build the new structure. Its builder was Robert Carter, and its first pastor, R. B. Townes, served for 26 years. (Photograph by Terry Miller, June 2007.)

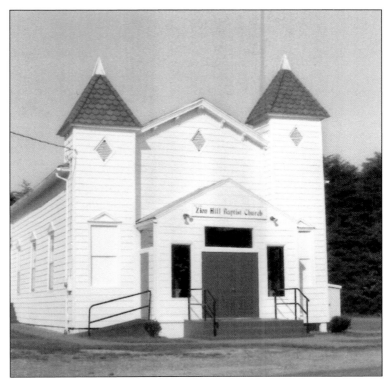

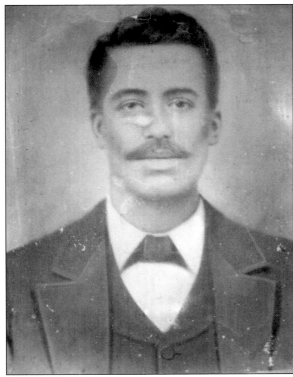

William Cook Jr. (1851–1900) wed Emily Johnson of Locust Grove, and the couple had eight known children. From his father's inheritance, which consisted of land patents passed down from as early as 1728, William and his brothers became some of the largest landowners in Spotsylvania. Their total exceeded 2,000 acres, which was soon known as Cooktown. (Courtesy Carrie Cook Washington.)

Junior choirs were new developments that came about as children cultivated more active worship roles. The Zion Hill junior choir poses in the 1940s. Pictured here from left to right are (first row) Ida Acors, Gracie Tyler, Marlene Carter, and Benny Cook; (second row) Ruby Acors, Julia Acors, Betty Jean Howard, and Mary Francis Acors; (third row) James Moody and Thomas Cook. (Courtesy 125th anniversary booklet.)

Begun from a church dispute at Little Mine Road, St. Paul's was a one-room structure with altar space and a cemetery next to a one-room school on what is now Post Oak Road. Its founding members included the Davis, Stanard, Ellis, and Banks families. The church survived for many years under the pastorates of William R. and William H. Banks. (Photograph by Terry Miller, May 2007.)

Weeping Willow Hall was where full-time farmer and part-time minister Leland Gordon led Bible lessons. Built by Rass White, it was the first worship center attended by many area children. Born around 1858 to Charles and Rosetta Gordon, who owned property valued at $300 as recorded in 1870, Leland Gordon married Agnes Smith, the daughter of Lewis and Louisa Smith, on January 5, 1880, and fathered seven children. (Courtesy Landonia Alsop Taylor.)

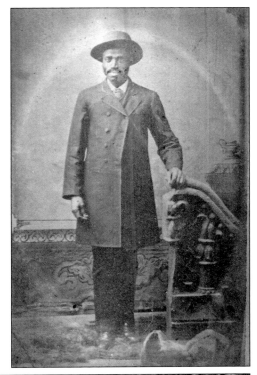

Mount Hope Baptist Church was established by Rev. Daniel Washington on October 8, 1898. After the group had been meeting in a brush arbor for more than a year, two and five-eighths acres were purchased from Bazil and Sarah Leitch. Rev. William Jackson assumed leadership and stayed with the church through the completion of the first structure. By the early 1940s, the vestibule and steeple had been added. (Courtesy Ida Lewis.)

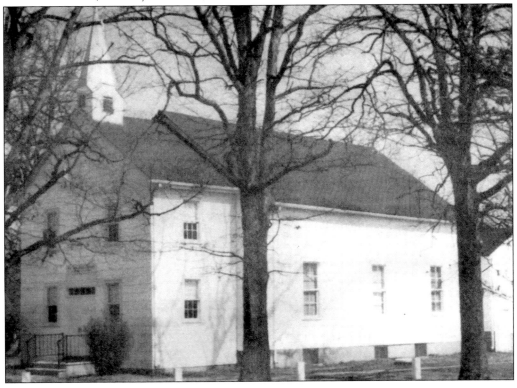

Thomas Ross served twice (1940–1942 and 1946–1948) as interim pastor. Born about 1874 to Archie and Agnes Gray Ross, Thomas wed Mary Ella, the daughter of Charles and Hester Hughlett, on February 26, 1903. Over the years, the couple had 11 children. Seen here at their home are Mary and Rev. Thomas Ross (foreground) with two of their children, Booker T. and Annette. Reverend Ross was pastor in 1948 during construction of the church basement. In August 1948, he passed the leadership to Rev. Marshall Robinson. On September 12, after a day of heavy rainfall that soaked the new foundation, people in their church best arrived for the annual revival celebration. One could hear singing from the raised windows: "I'll fly away, Oh Glory, I'll fly away." Suddenly the temporary floor began to give way and collapse—first on its right side and then completely—in what seemed like slow motion, swallowing dinner, desserts, purses, and even false teeth. The fastest exits were windows. The invited revival preacher, with shoes in hand, looked for an exit and exclaimed, "Damn a church with one door." There were plenty of short- and long-term injuries, but fortunately no deaths. (Courtesy Booker T. Ross.)

Two

WITH OUR HANDS

All kinds of work were necessary to meet the needs of Spotsylvania's African Americans. Since they did not have access to the jobs and opportunities of whites, many migrated northward once the Civil War ended in order to work in factories and perform construction projects.

Those who stayed made their living off the land, traded for the additional supplies they needed, and sometimes built their own equipment. For the community to grow, a mixture of skills—both blue- and white-collar—was required, especially since there was only a tenuous level of trust with the white majority. Everyone worked at something, and even though their names were not chronicled or their photographs taken, the society would not exist without them. Homemakers, undertakers, makeshift dentists, "spirits makers" during Prohibition, and gifted midwives such as Newtny Banks all had valuable jobs to do. John Tyler is one such person, the only recorded black physician in Spotsylvania's 1870 census record.

Men like Henry Samuels, Charles Coleman, Addison Watson Coleman, Thomas Braxton, Wallace Banks, and Frank Taylor will not be recorded in grade school history books, largely because they do not appear in any photographs and their accomplishments have gone unnoticed. While a slave, Henry Samuels lived and worked on the Dickerson farm as a stud, fathering an unknown number of children. Charles "Buck" Coleman taught his son Addison how to dig wells, and several incredibly brave men worked with them throughout the county, digging through and sometimes dynamiting rock in order to meet water.

To those men, and other men and women like them, this chapter is dedicated.

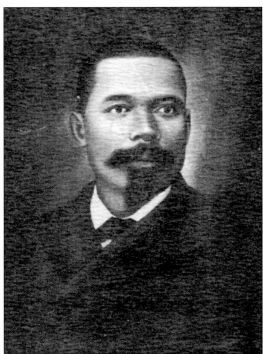

Born around 1810, Henry Alsop married the very young Mary Anne about 1855. He bought 100 acres from Noble Roberts for $500, cut trees, and built a log cabin where he and his wife raised their children. Alsop was a farmer, wheelwright, and blacksmith whose lasting legacy was giving his children a sense of purpose, community service, and achievement. (Courtesy *A Biography of the Homer J. & Mary E. Combs Family.*)

Arthur Fauntleroy was born around 1848 and wed Mary King in April 1875. The 36-year-old and his 21-year-old brother, Edgar, bought 83.75 acres on which they had a house built and raised everything they needed. This is one of the oldest homes in Spotsylvania that has been maintained entirely in its original condition and is still inhabited by descendants of the first owner. (Photograph by Terry Miller, August 2007.)

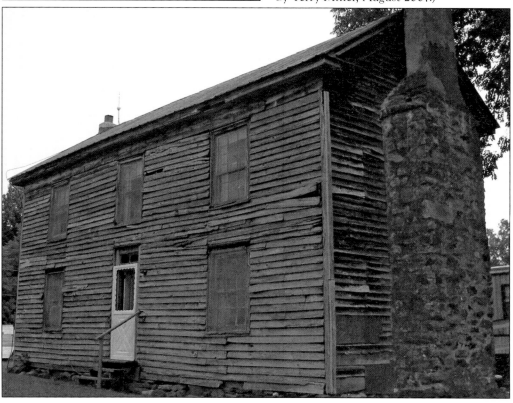

Born about 1847 to B. and Ellenor Howard, Constance Howard learned the high art of shoemaking and made his living that way, traveling to different cities to buy leather. One of the founding members of First New Hope Baptist Church, he married Melvina Thornton, the daughter of blacksmith Emanuel and Dinah Thornton, on January 5, 1871. The couple had nine known children; only four had survived by 1930. Grandchildren left without their mothers were raised by Constance and Melvina. When they first married, Constance was living and working in Washington, D.C. In both 1872 and 1873, the couple opened bank accounts through the Freedman's Bureau. (Courtesy Melvin Thompson and family.)

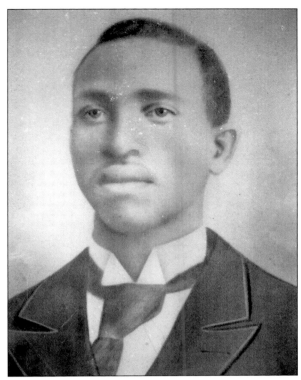

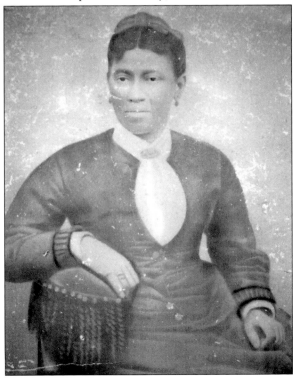

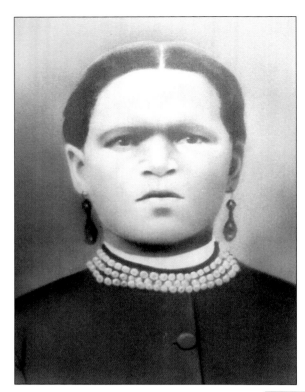

Dolly Carter Stanard Lawson, born around 1853, was one of nine children of Solomon "Saul" and Maria Carter. Dolly began her work life as a domestic servant. By 1880, she had married Robert Stanard. Before his death, they had five children. She remarried to established landowner and widower Isaac Lawson on March 31, 1897. An heir to both her first husband's and her father's estate, Dolly was a substantial landowner in her own right, as were her two surviving siblings, Mansfield and Louise. (Courtesy Shirley Lawson Robinson.)

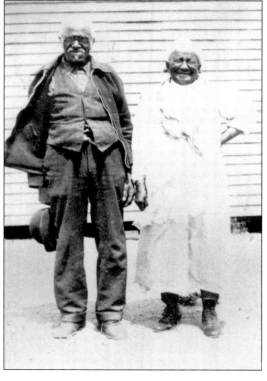

James Lewis was born about 1857 to Peter and Melvina Lewis. On October 8, 1885, he married Eliza, who had been raised in the Samuel Diggs household. Working first as sharecroppers and then cultivating their own 23 acres, they birthed and raised 13 children—10 boys and 3 girls—who all lived to adulthood. (Courtesy Ruth Lewis Wood.)

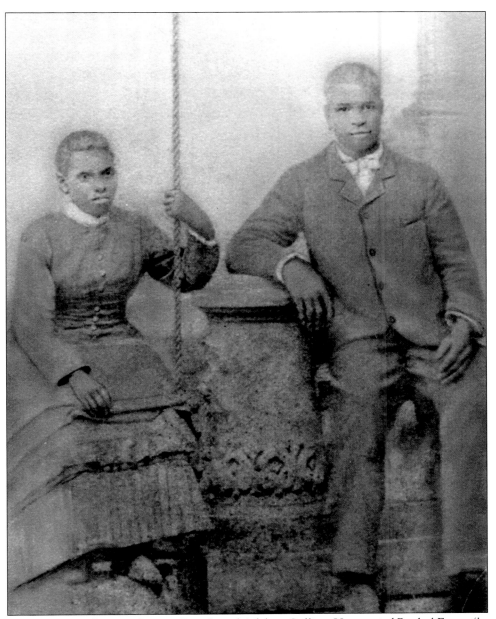

In 1859, Henry Collins was born to Joseph and Adeline Collins. He married Rachel Frazer (born about 1869), the daughter of William and Mary Frazer, on November 5, 1885. Together they bought 35 acres on what is now Talley Road and raised nine children there. Once their children were adults, all left Spotsylvania to move north, where opportunities were greater and the day-to-day humiliations of post–Civil War black life were fewer. Eventually one of their daughters, Augusta, moved home after marrying Robert Lee Lewis and having three children. As a grandmother, Rachel snuck up on her grandson Leon when he was hitting against the side of the house after being told to stop. When she got close to him, she reached under her apron, pulled out a stick, and whacked him. He was fast, though, laughing and getting away from her quickly. (Courtesy Leon Lewis.)

Known for his stiffly starched shirts and stand-up collars, William Stanard (c. 1867–April 4, 1938) was a man of particular taste in habits, dress, and friends. The second known child of Beverly and Frances Stanard and the grandson of Beverly Sr. and Winnie Stanard, he worked as a cement finisher, traveling in the spring and summer building roads. On February 23, 1904, he wed Mary Nelson, an independent, educated 26-year-old farmer and daughter of Henry and Emma Frazer Nelson. They had five children, to whom William read the weekly newspaper. After being married for 34 years, William died at the age of 66. The shock of his death took an even greater toll on Mary than that of her son years earlier. Inconsolable, she refused to eat and, after three weeks, collapsed and died. (Courtesy Constance Braxton.)

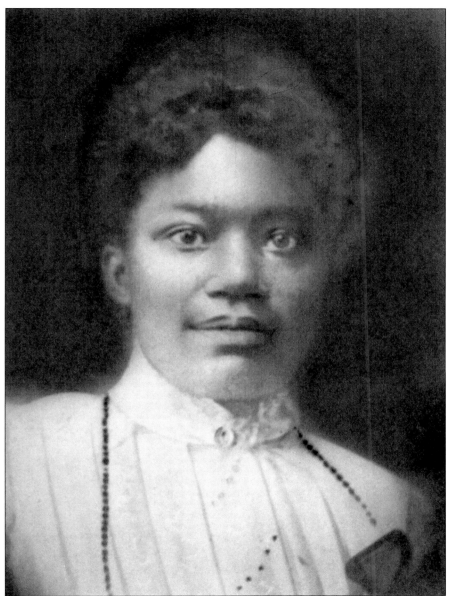

Born to Samuel and Rosanna Samuels Diggs on April 6, 1872, Nancy Diggs grew up knowing hard work. She married William Henry White and built a home on spacious land situated on a hill off a curvy Route 208. Coming from a tradition of growing up with foster children, she too opened her home and helped countless children. Because cars, trucks, and buses could not get up the hill during bad weather, travelers often found themselves at Nancy's table, and when it was time to go to sleep, she made a place for them. Drifters were even welcome to eat at her table and sleep in her home in exchange for work in the fields. She farmed her 40 acres during planting and harvesting season; during the winter, she traveled to New York and worked as a cleaning lady in hotels. Known for paying cash for her purchases, Nancy would smile and say, "I'm not owin' no man nothin' but love." She died on April 11, 1969, at the age of 97. (Courtesy Miriam White Pendleton.)

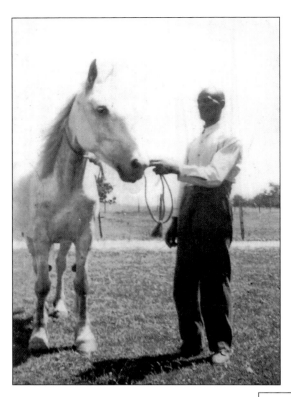

Billy was the favorite horse of Edgar Smith (1875–1948), whose known Spotsylvania heritage began with his grandfather Thornton (born about 1795). In 1907, Edgar married Lena Ford and went on to father nine children. While farm life may have been the necessity for Edgar, it was not the life he and his wife wanted for all of their children. (Courtesy Beatrice Smith and Dorothy Smith Moore.)

On a bright, sunny day each spring, all furniture and accessories were taken outside for cleaning. Tick mattresses and rugs were beaten, left in the sun for natural purification, and brought in before the evening's dew. Rugs were purchased at local general stores like Mrs. Huff's, E. B. Finney, and Scott Perry's, which carried everything from linoleum rolls and hammers to socks and flour. (Courtesy E. Jean Lewis.)

Born in 1876, John William Cook was the fifth child of William Sr. and Catherine Acors Cook. His father was a large landowner with $715 in reported real estate and personal wealth in 1860. John William married Martha, and while they did not have any children of their own, they helped many others and taught them how to live independently. John William operated one of the biggest road-building crews in the area (below). In addition, he always cultivated his land so that the family only needed to buy specific things from the local market. He ordered baby chicks by mail, rode his horse and buggy to the depot to retrieve them, and raised them in his coop. When he became ill in his old age, his daughter-in-law Gladys Cook nursed him until he died in 1964. (Courtesy Gladys Carter Cook.)

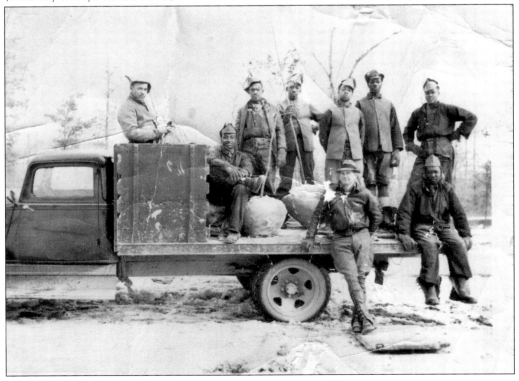

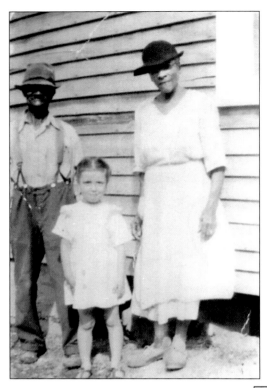

Jefferson Catlett was born around 1865, the second son of Sarah Catlett. He first married Susan Comfort, the daughter of Charles and Lucy Comfort, in 1888. Six known children later, the couple divorced. After some years, Jefferson married Lucy Watson (shown), the daughter of Sallie Watson, and worked as both a farmer and a household hints book salesman. A little girl named Diane (pictured here) lived nearby and regularly visited to amuse the couple. (Courtesy Carrie Cook Washington.)

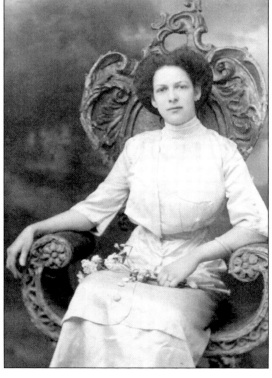

Julia Lee (1889–1973) was the daughter of her namesake, Julia Lee (born about 1858), and John T. Payne (born about 1837) of Orange County. In 1897, her mother purchased 147.5 acres in Spotsylvania from her father's estate for $500 cash and moved there with her two children: little Julia and the elder Samuel. (Courtesy Julia Pryor Fauntleroy.)

Aaron Thomas Pryor (1881–1962) was one of eight children born to John and Keziah Frazer Pryor. In 1912, he married Julia Lee. After living and working for a short time in Philadelphia, Aaron and Julia moved back to Spotsylvania, where they raised their four children, worked their farm, and sold milk to Farmers Creamery. Aaron's three chicken houses produced 90 dozen eggs every week. Aaron was of average height, while Julia was tall and seemed only to grow taller over the years. Their grandchildren included the following, from left to right: (seated on the ground) Ronald Brown, Malcolm Pryor, Joyce Brown, and Merritt Brown Jr.; (standing) Geraldo Pryor, Garland Pryor, and Althea Pryor. (Right courtesy Beatrice Byrd Lewis; below courtesy Thelma Robinson Pryor estate.)

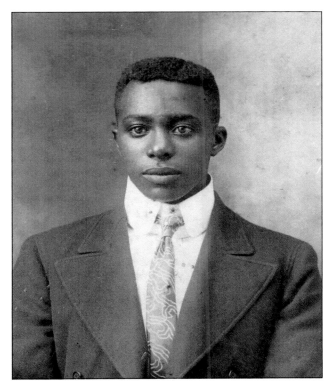

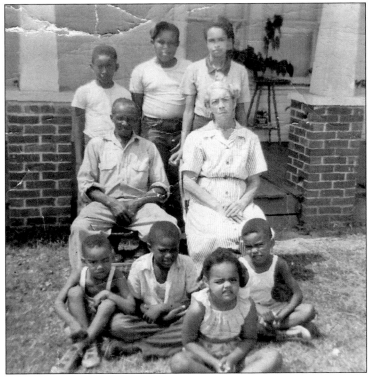

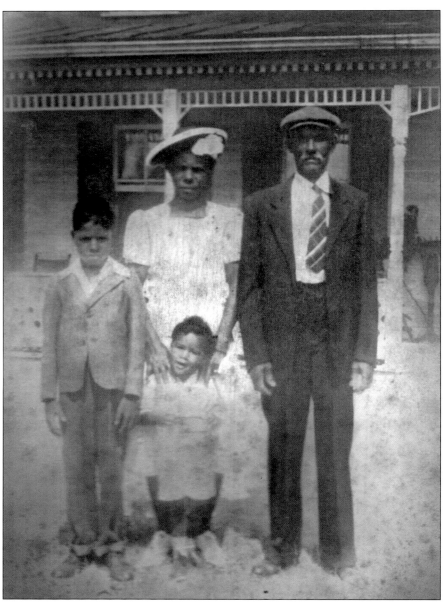

Born in 1878, Alfred "Allie" Linwood Fairchild went to school only one day in his life but could quite simply visualize and build anything. He married Alberta Garnett in 1899 and fathered three children. After her sudden death, he wed Rosa Lewis, the daughter of James and Eliza Lewis, and the couple had nine children. Above are Allie and Rose with their son Roy and grandson Aaron Jr. Allie's personal ethics were legendary, and his body of work, which included houses, barns, silos, and schools, was unparalleled. Everybody marveled at his ability to cut almost the exact amount of lumber needed for a project, lay it out in the formation he thought best, build, and end without waste. He was the first black person in the county to own a car, which he kept in the barn except when used for special occasions like chauffeuring newlyweds Percy and Essie Combs Reed to their reception on August 6, 1913. In February 1950, while doing what he loved—working—Allie suffered a stroke and died within hours. (Courtesy Rosemary Quarles McKinney.)

The son of Marshall and Esther Banks, Eddie Banks (1876–1957) married Wilmonia White and raised five children. In addition to farming, he cut and skinned oak trees and weaved intricate yet utilitarian baskets of varied shapes and sizes, to be sold throughout the community. (Courtesy Josephine Alsop.)

Winnie Stanard (1880–1946), the daughter of Robert and Dolly Carter Stanard, wed Archie Garnett in April 1896 and bore 10 children. Because Winnie needed to earn more money than she could as a local cook, her sister Cora referred her to a higher-paying job in Warrenton. Archie became gravely ill while she was away, and at Christmas 1933, she returned home to nurse him. He died in March 1934. Winnie died of stomach cancer 12 years later. Hers was the first grave in Sylvannah Baptist Church's cemetery. (Courtesy Christine Garnett Chapman.)

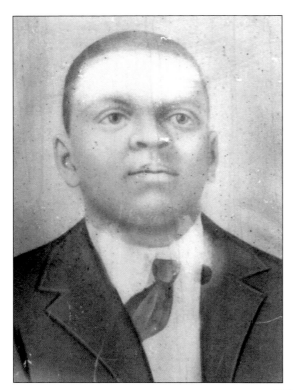

Elmore Lawson, born on January 26, 1882, to Isaac and Julia Weathers Lawson, was a farmer, carpenter, and construction contractor. He married Cora Stanard on November 22, 1900, and fathered 17 children. Long after Cora's 1938 death, he married Lizzie Matilda Nelson. On his vast acreage, Elmore operated a sawmill and built a baseball diamond, where the Spotsylvania Yellow Jackets became the main draw. (Courtesy Shirley Lawson Robinson.)

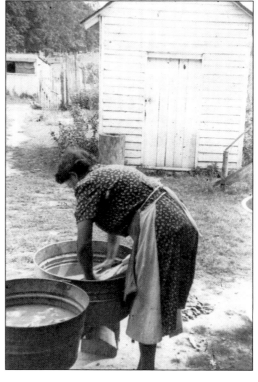

Wash day required at least two tubs of water—one each for washing and rinsing, and a third for bluing—a washboard, and lots of arm strength. The warm weather did not pose as large a problem as the cold. When frigid outside, it was a feat to hang clothes on the line before they froze. Here Annie Bell Terrell handles wash duty. (Courtesy Deborah Terrell Smith.)

Christianna Carter, born about 1885 to
Warner and Ede Carter, was a laundress
with her own clientele. She married
Thomas Braxton, the son of Dallas and
Lydia Catlett Braxton, on March 13, 1907.
In her business, Chris washed, dried,
ironed, starched, and neatly folded shirts
high in a big straw basket, which her
son then delivered back to the clients.
(Courtesy Constance Braxton.)

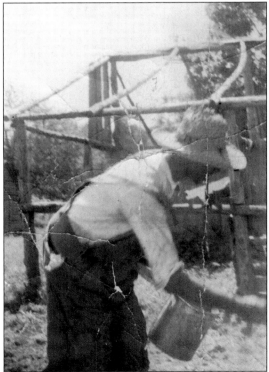

Ira Moss, born around 1883 to
Richard and Lucy Ann Moss, married
Irene Thornton. She was qualified to be
a teacher but stayed home at his request.
When his two daughters came of age, they
moved north to work and sent money
home to help with expenses. Ira was well
known for his bass singing voice at church
and the springtime whitewashing of his
house. (Courtesy Alice Moss Taylor.)

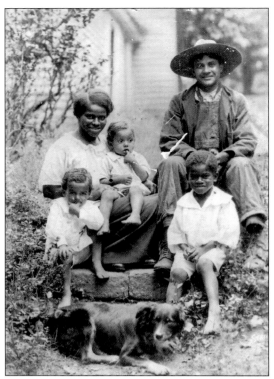

Shown are Maxwell "Mack" Dixon; his wife, Victoria Elizabeth Lewis Dixon; and his sons Harry (left), Melvin (on Victoria's lap), and Maxwell Jr. By 1900, when Mack was six, his mother had died and his grandmother Emma Dixon was raising him. They lived in the Alms House, headed by James Ball and his family in downtown Fredericksburg, with 10 other people between the ages of 45 and 84. The only person Mack's age was the owner's son. Mack worked on farms and learned about dairy farming and animals' medical needs. In the process, he learned how to read. While working on the Rowe farm, he wed Victoria Elizabeth Lewis on March 18, 1918, and they moved to her parents' farmland. Both Mack and Vic were veterinarians. Along with his animal care supply box (below), Mack's prized possession was a book titled *The Veterinarian* by Charles J. Korinek, signed and given to him in 1919 by M. B. Rowe. (Courtesy E. Jean Lewis.)

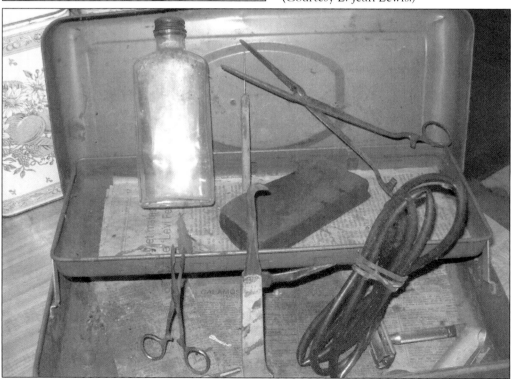

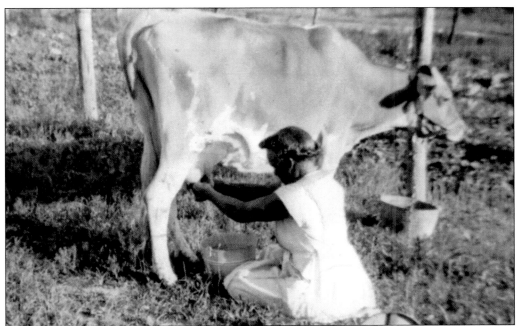

Victoria Elizabeth Lewis Dixon was born to James and Eliza Diggs Lewis on April 10, 1886. One of 13 children, she was sent to work in different cities as a child. Victoria outlived her siblings, finally succumbing to old age at 111. Throughout her life, she was known for being completely unafraid. She chopped her own wood, handled a shotgun like a sharpshooter, gutted livestock like a ranch hand, de-scented skunks, and repaired vehicles like a licensed mechanic. She also sang in Sylvannah's choir and served as a church custodian, bus driver, deaconess, and missionary. She often delivered mail on her brother Preston's route from Snell to Paytes. When asked how many children she raised, she replied, "How the devil am I supposed to know?" Below is the syringe she and her husband used when treating animals. (Courtesy E. Jean Lewis.)

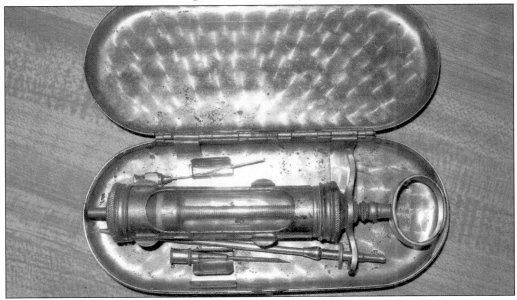

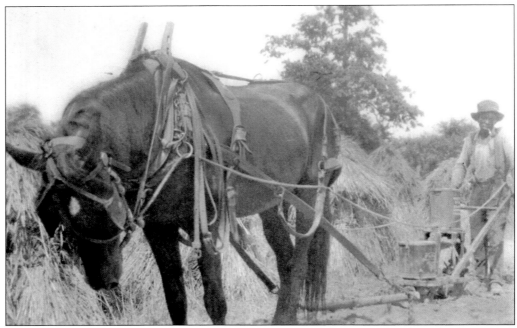

Getting tasks done on the farm became a little easier with horses and mules. The latter were preferred for fieldwork because they moved slower than horses. Doing his daily work is Richard Byrd, born about 1889 to James and Mary Byrd. (Courtesy Beatrice Byrd Lewis.)

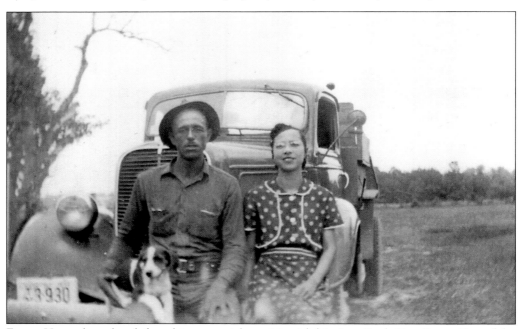

Ernest Hart takes a break from his sawyer job to visit with his sister Ruth Hart Pryor. One of the few men with a vehicle, he traded rides to the grocery store for milk and butter. Ruth remained unmarried for a very long time, earning her living as a housekeeper. She eventually married one of her client's sons, Pleasant "Pless" Pryor Jr. (Courtesy Roganna Howard Rollins.)

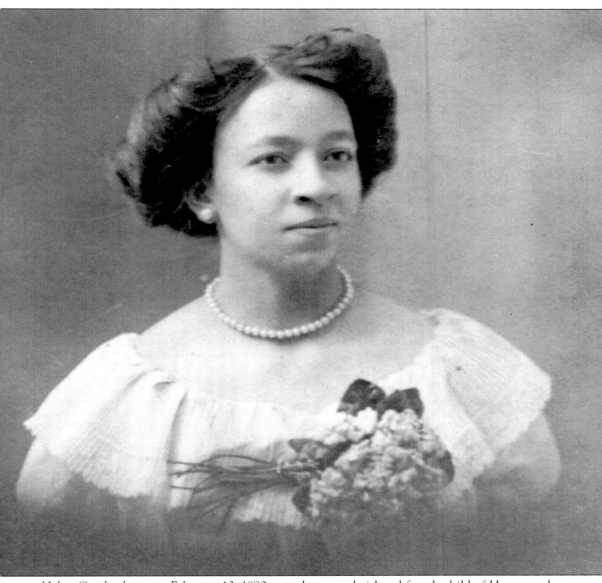

Helen Combs, born on February 13, 1890, was the second girl and fourth child of Homer and Mary Ellen Alsop Combs. Later in life, she reminisced about how she and her sisters were not permitted to play as children, but were expected to sew, cook, clean, read, or tend the 223-acre farm that their father had purchased from L. R. and Daisy Colbert. Helen's oldest brother died in infancy. The second son had health problems, so Helen's opportunities to leave the farm were limited. Understanding the ways in which rural life could be easier, she wanted to marry a minister. Rather, in 1911, she married farmer Edgar Lee, and their union lasted almost 58 years. Unlike her four younger sisters, Helen could not further her education. Yet her discipline was evident through her daily ritual of caring for her skin and her work of more than 40 years as a nurse-midwife. (Courtesy Julia Pryor Fauntleroy.)

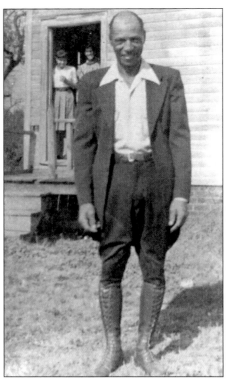

Milton William Terrell was the 11th known child of Julian and Sarah King Terrell. He was born on November 30, 1900, and married Nellie Bly Woodward on August 9, 1922. Milton worked on the Oakley farm for 50 years with his father and older brother Julian Jr., but whenever he could, he dressed for the equestrian shows in Culpepper, packed a lunch, and loaded his buggy for the ride. (Courtesy Brenda Terrell.)

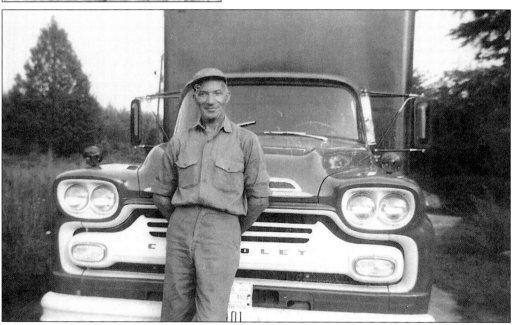

Born on the Pierson farm in 1903 to Willie and Janie Williams, Lafayette Williams wed Hattie Turner, the daughter of Thomas and Salina Carter Turner. The first known African American milkman, Lafayette delivered to Richmond for more than 50 years, returning often with beef for local markets. (Courtesy Second New Hope Baptist Church archives.)

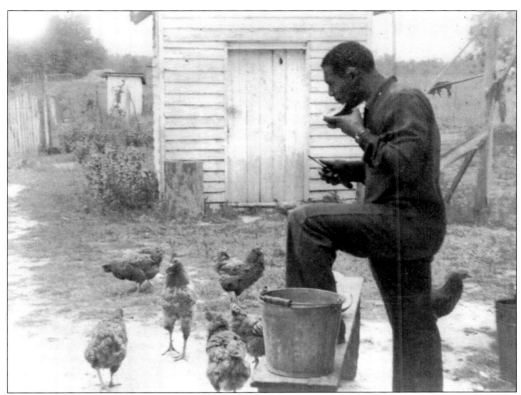

Working the farm is all about chores, and one of them is feeding the chickens. But what if you were hungry yourself? Here a farmer takes a fast lunch break, eating a melon he picked from his garden. (Courtesy Deborah Terrell Smith.)

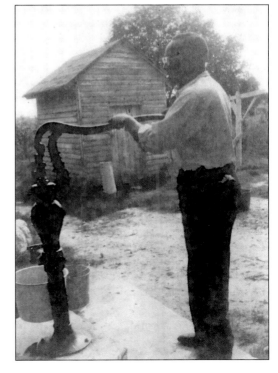

Unless a natural spring ran through one's land, all necessary water came from a well. Progress was made when the well was hooked to a pump rather than a bucket and rope that could easily break. (Courtesy Deborah Terrell Smith.)

Just call Preston Lewis (1904–1995) the everyman's builder. After retiring from the Food Manufacturing Company (FMC), he worked for more than 40 years as a self-employed carpenter. Lewis created one of the first buses that carried children back and forth to the Spotsylvania Training School. In his later years, he specialized in dollhouses for neighborhood children. (Courtesy E. Jean Lewis.)

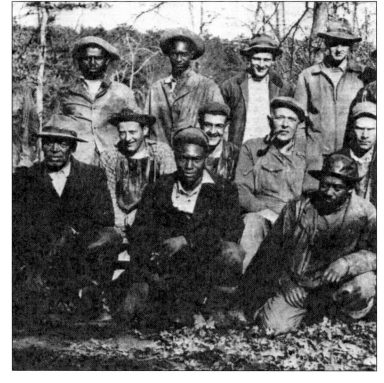

Mining for lead, zinc, silver, and even gold was a key industry in Spotsylvania from before the Civil War to the 1940s. At the Whitehall Farm are the following, from left to right: (first row) Andrew Jackson, Harvey Minor, and Clifton Banks; (second row) William Turner, Willie Oaks, unidentified, and Jimmy Leach; (third row) Sylvester Banks, Rufus Minor, Lindberg Sullivan, and unidentified. (Courtesy Jean Dobyns.)

Posing with 11-and-a-half-month-old pigs is C. L. Brickhouse on a December visit. The size and age of the pigs along with the time of year meant that some of their meat was a candidate for the Christmas dinner table. (Courtesy Alfred C. Fairchild and family.)

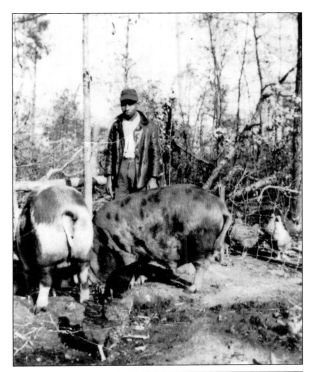

Herbert Starr Byrd (1921–1994), taking a break from a hard day's work, shows off a new colt to three visiting friends from New York (seated around Herbert). Standing are Thomas Shepherd (left) and Bill Lewis. Seated in the background, wearing her wide-brimmed straw hat, is Mary Byrd Logan. (Courtesy Beatrice Byrd Lewis.)

Known as one of the best concrete men around, Joseph Pierce (1901–1972) was part of a three-man crew that included Elison Burrell and Irvin Braxton. They would leave Spotsylvania on Sunday night in Joe's car and stay away all week laying large amounts of concrete at airports and building roads. Born with his twin sister, Ruth, on April 11, 1901, Joe was the son of Robert and Jenny Pryor Pierce and the grandson of John and Keziah Pryor. He also had two brothers: Rudolph and Robert. Joe attended through the fourth grade the one-room Piney Branch School, where he was in class with his future wife, Annie Bell Woodward (below), the daughter of Benjamin and Mary Lee Woodward. Once married, the couple had five children. Annie lived another 22 years after Joe's death. (Left courtesy Cynthia Hill; below courtesy Julia Pryor Fauntleroy.)

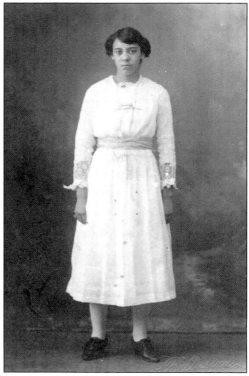

Fannie Howard (born around 1913) was the middle daughter of Abner and Mary Howard. Her father (born around 1871) was a farmer who also knew how to build. The family home was a 14-room two-story farmhouse where Abner and Mary raised their four children (their son Ernest died of tuberculosis in 1923). As was tradition, one daughter was chosen to stay home while the others were allowed to leave for a better education. Fannie was chosen to remain. After Fannie's mother died, she took over the care of the home, a place where she raised more than 40 foster children and nursed her father until he too died. In this photograph, Fannie assists William Byrd Jr., who was born with crooked ankles. The doctors broke them both and cast them for two years. Fannie helped strengthen his ankles by teaching him how to ride a tricycle. (Courtesy Roganna Howard Rollins.)

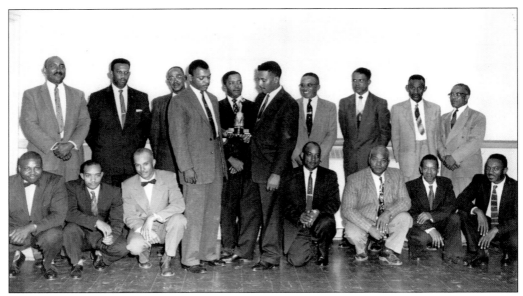

Opened in 1930, the FMC plant was the largest local employer. Here C shift has just received its trophy for a winning softball season. Pictured from left to right are (first row) Thomas Johnson, James Walker, Aaron Fairchild, James Griffith, Alex Norman, Nehemiah Catlett, and Thomas Taylor; (second row) William Griffith, Cecil Jones, Walker Tolliver, William Catlett, Booker T. Ross, Roger Braxton Sr., Clinton Braxton, Hampton Winn, Mansfield Smith, and Preston Lewis. (Courtesy Booker T. Ross.)

Marion Thomas Fauntleroy (1920–2005) worked for FMC. Needing an economical way to keep his family warm, he built a wood-burning stove that is still their one source of heat during cold months. Marion was the son of William McKinley and Ruth Pierce Fauntleroy and the husband of the former Mary Williams of Wake County, North Carolina. (Photograph by Terry Miller, July 2007.)

One of four daughters born to Edgar and Lena Ford Smith, Beatrice Smith (born in 1919) was the trusted housekeeper and nanny for a prominent Fredericksburg family. With tremendous interpersonal skills, a nature that demanded respect and attention, and a quick mind that could learn anything, she decided at age 50 to learn to drive. Her very first car was the Plymouth she used to drive her employer, presented as a gift. By the time Bea retired, she had received four cars from her employer, who only trusted her to drive them from place to place. Showing her natural abilities again later in life, she taught herself how to bowl, joined a league, and won every available trophy. (Courtesy Beatrice Smith.)

Ruth Lewis Wood was the third child of Henry and Blanche Coleman Lewis. She remembers both drawing water up from the well and lowering butter down to keep it cool. She married James Edmond Wood (1923–1976) and moved to Washington, D.C., to work for the U.S. Veterans Administration. Ruth's professional life, however, did not subsume her talent for drawing, painting, and sculpting folk art inspired by scenes of rural central Virginia. For example, while she and Edmond were sightseeing in Westmoreland County, she saw a man working with his oxcart. When she got home, she walked to the nearest creek, made clay, and sculpted the entire scene. A true artist, at times Ruth picked up a pencil and sketched the expression on an animal's face or took inspiration from the family mules, Maude and Mae. (Courtesy Ruth Lewis Wood.)

When Dorothy Smith graduated from Spotsylvania Training School in 1945, there were more opportunities to leave for city life. She was the youngest child of Edgar and Lena Ford Smith. Dorothy's mother told her adamantly that she did not want her to graduate just to stay in the area and work in somebody's kitchen. Dorothy joined her sister and brother-in-law in New York and eventually found work at the famed Gimbel's department store. (Courtesy Dorothy Smith Moore.)

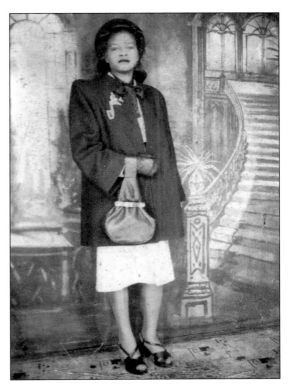

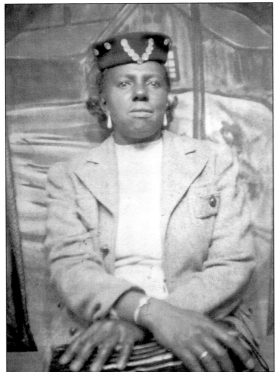

Catherine Clark Lewis was married to Elton Lewis. They bought the first bicycles in the neighborhood for their children and always made sure the household had fresh batteries for the radio so they could all gather around and listen to Joe Louis's boxing matches. A superb seamstress who made everything, including undergarments from sackcloth, Catherine had a large and diverse clientele. (Courtesy Ida Lewis.)

SERVING OUR COUNTRY

At 22, Spotsylvania native Charles Edward "Sonny" Dyson Jr. (1934–1966) became the first black policeman in Fredericksburg. The son of Charles Sr. and Rosa White Dyson, he was chosen because of his experience in the U.S. Army and his temperament. His single task was to keep order in the 300 block of Princess Anne Street, where he was not allowed to arrest anyone other than fellow African Americans. He came to the police department after learning counterintelligence, serving two special duty assignments at the Pentagon, and teaching at the Army Signal School in Camp Gordon, Georgia. He later used his experience and entrepreneurial skills to start the first Police Boys Club, open and operate Sonny's Record Shop and Sonny's Soda Fountain, and keep the public informed as a radio disc jockey. (Above courtesy Miriam Dyson Pendleton; right courtesy James Dyson.)

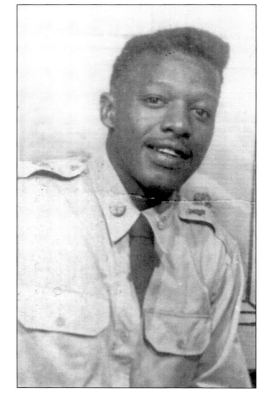

Clifton Tyler Sr., the son of Henry and Harriett Duerson Tyler and the husband of Bertha Childs, invested in building and operating the Oak Lodge in the early 1930s with his nine-year-old son Cliff's $3,000 reward money after returning lost jewelry. Bertha's wisdom insisted that he invest the money in Cliff Jr.'s name so that when he came of age, he would own real estate and a business. Cliff Sr. also used the money to send his son to college and his daughter, Louise, to nursing school. Cliff Jr. was special. At 21, he contracted tuberculosis when working in Philadelphia, and although he was treated, the disease lingered. He became so sick that he was admitted to Freedman's Hospital in Washington, D.C., and treated aggressively by Dr. Charles Drew, who removed Cliff Jr.'s entire right lung and part of his left. His sister resigned her commission as an army nurse and, for 19 months, nursed her brother from certain death. He recovered to become a schoolteacher, commuting to Stafford and then later to Washington, D.C., and still kept his business operating smoothly. (Photograph by Terry Miller, April 2007.)

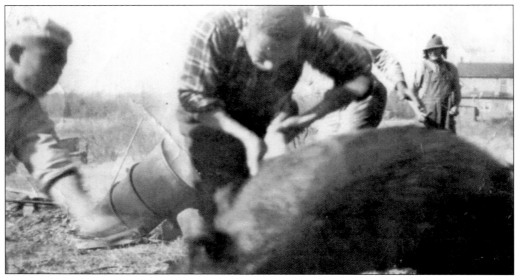

The biggest December rituals were hog killing and cleaning. Teams of men decided on specific jobs, and timing was critical. Who would kill the hogs? Who would dig the pit and fill it with scalding water? Who would skin them, castrate, and clean the entrails? Who would gut, remove, and hang their livers? Who would cut and cure the meat? The work occurred before Christmas when the temperature was cold enough to ensure the meat stayed fresh. The killing was the toughest part because children heard the pre-dawn anguished squeals. The children had just fed and played with the piglets and hogs the previous day and given each a name. On Christmas day, however, there was fresh pork to eat with extra stored through the year. (Above courtesy E. Jean Lewis; below courtesy Clinton Braxton Jr.)

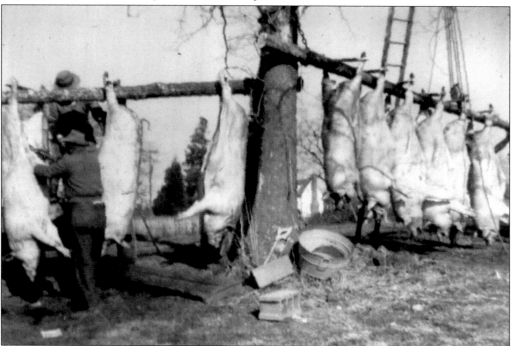

Three

IN OUR SERVICE

Organizations form because people need one another. The individuals who comprise them are passionate about causes. This was particularly true in the days after slavery and post-Reconstruction.

Through brotherhoods of Freemasons and their corresponding sisterhoods, educational associations, religious fellowships, political connections, and even sports teams, formal and informal networks were established, codes of conduct were devised and expected to be followed, social problems were addressed, people were encouraged, and friendships were cemented.

These associations could not have thrived without the work of countless people whose names have hardly been mentioned. One such person is Virgil Williams (1867–1945), the first child of Minor and Kate Williams. At a young age, Virgil went to live with his uncle Ira White. He became the first black mail carrier to deliver mail throughout Spotsylvania and Caroline Counties. After marrying Ruth Wright, the daughter of Woodson and Louisa Wright, in 1899, he fathered 11 children. In addition to carrying mail, Virgil first worked at and then owned, along with his partner, Dick Brown, a sawmill. In his older years, he retired and farmed his land. Even though he worked all the time, he was an active behind-the-scenes man in his church and in every organization designed to uplift Spotsylvania African Americans. He even led a workshop about the church's purpose and program for the Rural Church Institute.

To Virgil Williams and those interested in results more than recognition, this chapter pays homage.

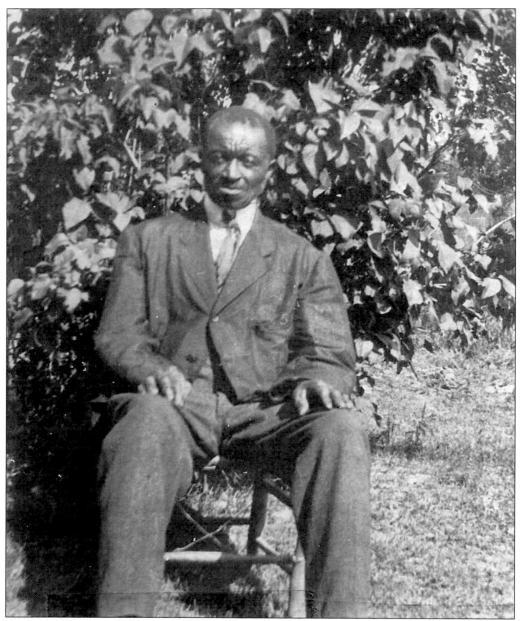

Lewis Terrell (c. 1858–1929), a former slave and sharecropper, was the son of William and Harriett Dudley Terrell. In 1882, he bought 60 acres from the Benjamin Jenkins estate, and in 1884, he married Rosa Spencer (1865–1947), the daughter of James and Louisa Spencer. They had 19 known children. A leading trustee for Branch Fork Church, Lewis understood what it meant to scrape and save and use one's own money to buy land, as he had purchased more than 160 acres in his lifetime. This he instilled in his children, along with a sense of service beyond oneself. At his death, three of his friends were chosen to appraise his personal property and sell what his heirs did not want. His personal items were appraised at $75.50, with his most valuable possession being his mule. (Courtesy Anita Terrell Roberson.)

Because their rites were secret, members of Prince Hall Masonic Lodge Prospect No. 121 were best known for laying cornerstones and conducting last rites. Their origins date to 1905, when 15 men met at Henry Ross's home to form a supportive brotherhood. One founding member was Lucian Comfort. Born around 1861 to William Lewis and Fanny Comfort, as a young man he worked as a servant for Dr. C. G. Powell. He became a carpenter and served as the chief architect and builder of Branch Fork Baptist Church. Twice a widower, in 1897, Lucian married Blanche Gordon. He drowned in April 1908, his death acting as the first test of brotherhood for lodge members. The group paid Lucian's burial expenses and gave a stipend to his widow. (Right photograph by Terry Miller, April 2007; below courtesy Lillian Hart Brooks.)

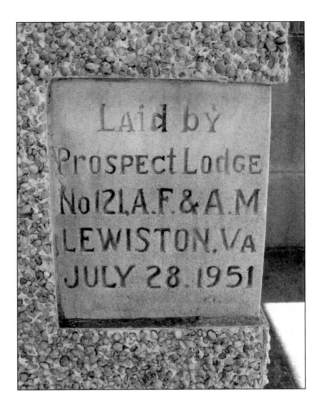

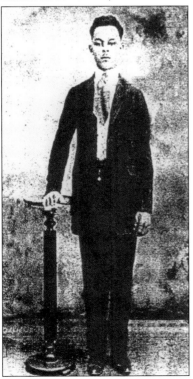

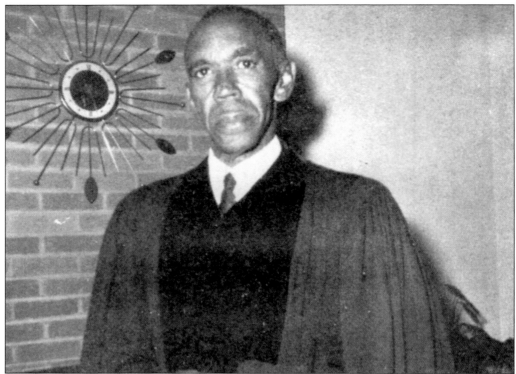

One of the early contributors to the success of the Sunday School Union was Joseph Despot (1914–1986). Son of Preston and Sarah Taylor Despot and grandson of James and Nancy Despot, he was named after one of his uncles. "Uncle Joe" (1895–1949) was an animal lover who built exquisite barns, one of which became the Fredericksburg Sheraton Hotel (below). "Little Joe," however, was best known as a minister, president of the Sunday School Union, and executive board member of the Mattaponi Association of Virginia. Lesser known is that he was salutatorian of his class, was drafted into World War II after serving one year at Virginia Seminary in Lynchburg, and was trained in mechanical dentistry. He earned his bachelor of arts and bachelor of divinity degrees from Virginia Union, continued his education at Virginia State and the University of Virginia, was a master mason of Prospect Lodge No. 121, and excelled as a teaching principal in Louisa. (Above courtesy Constance Braxton; left courtesy Fredericksburg Hospitality House and Conference Center.)

Mary Ella Alsop Combs (1868–1946)—the daughter of Henry and Mary Alsop, wife of Homer Combs, and mother of 10 children—was a courageous pioneer in missions. She traveled throughout the area and spoke to groups of women about the selfless caring of others and how to organize themselves to meet the needs of the sick, bereaved, persecuted, and hopeless. (Courtesy centennial anniversary booklet, Sylvannah Baptist Church.)

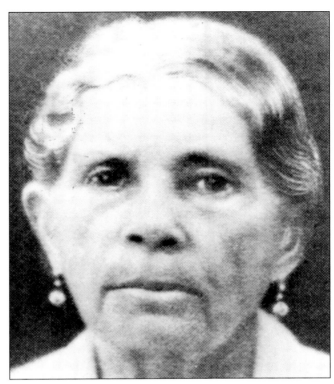

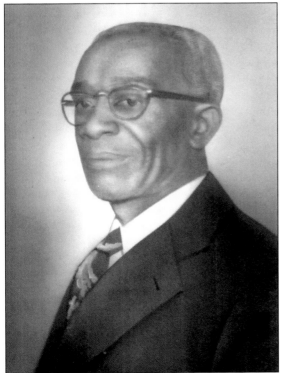

The Mattaponi Baptist Association began around 1879 as a fellowship of churches in central Virginian counties. The group's objective was to promote the cause of brotherly relations, provide mutual counsel, and foster Christian education, home and foreign mission, and evangelism. One advocate was Sylvannah Baptist Church deacon Frederick Tyler (born in 1883), the son of Henry and Harriett Deurson Tyler and husband of Bessie Fairchild Tyler. (Courtesy Peggy Tyler.)

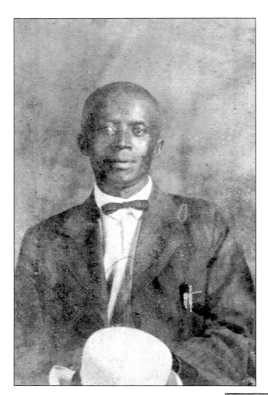

The NAACP opened a Spotsylvania branch in 1939 with Rev. Fennell Terrell, the oldest son of Lewis and Rosa Terrell, as its first president. The group received its charter in 1950. Others who served as president were Arthur Clomax, Nelson Hughlett, John Coleman, George Miller, Rev. Charles Franklin, and Thomas Jones. (Courtesy Deborah Terrell Smith.)

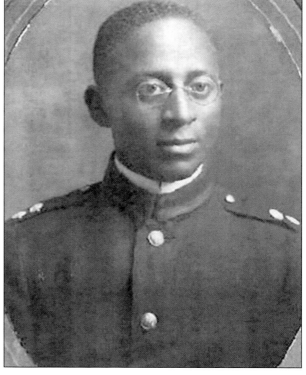

James Terrell, a son of Lewis and Rosa Terrell, was active in many aspects of Spotsylvania life. Most noted was his help with the NAACP. James persuaded famed attorney Oliver Hill of Richmond to come to the county and advocate for a young black woman who was the victim of an assault by a white man as she was walking home carrying a bag of groceries. (Courtesy Anita Terrell Roberson.)

Led by Ethel Dandridge, the Rural Church Institute of 1945 addressed the slow erosion of the important traditions that had made the rural church strong and given it meaning. For example, Augustus "Gussie" Collins Lewis (right, 1900–1978), the daughter of Henry and Rachel Collins and wife of Robert Lee Lewis, focused on the training departments such as the Baptist Training Union, missions, and the church school. Another participant, Bessie Fairchild Tyler (below), shared her expertise in church music. Bessie, born to Susan Fairchild about 1881, was the wife of Frederick Tyler and mother of five sons. Like many other women who grew up with pianos ordered through the Sears catalogue, Bessie learned music at a young age, beginning with spirituals such as "Rock of Ages" and "Jesus, Lover of My Soul." (Courtesy Leon Lewis and Peggy Tyler.)

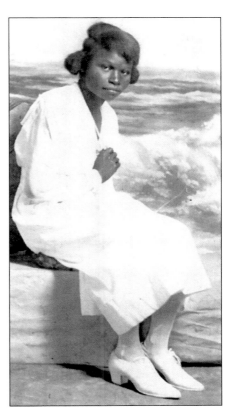

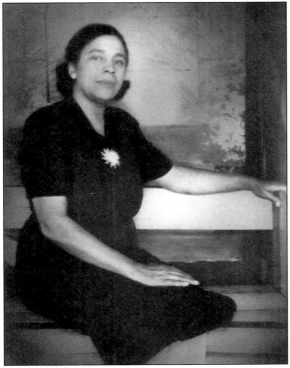

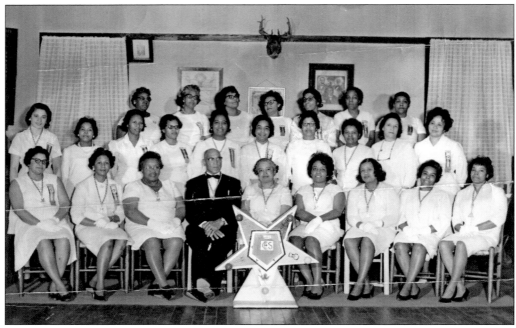

The largest fraternal organization for women in the county, Order of the Eastern Star, consisted of members who all had a direct relationship (wife, widow, or daughter) with local Freemasons. The group was always busy with benevolent causes and did much to foster sisterhood and positive character among local youth. (Courtesy Alfred C. Fairchild and family.)

Born on January 22, 1922, to James Henry and Fannie Stewart Cook, Carrie Cook married George Mason Washington in 1947. She became a member of the Celestial No. 38 Order of the Eastern Star, where she rose to the highest position of Worthy Matron. (Courtesy Carrie Cook Washington.)

Engaged in every aspect of education, Thelma Robinson Pryor chronicled all aspects of Spotsylvania. One association in which she was active was the Mattaponi Woman's Missionary and Education Convention, founded in 1906 to promote missions and education among Baptist women. Born in 1914 to James Henry and Clara Brooks Robinson, Thelma married A. Gratton Pryor, and together they had three sons. (Courtesy Thelma Robinson Pryor estate.)

The Sylvannah Family Community Education Club, established in the early 1950s, hosts an annual scholarship program to honor its founder, Hester Fairchild Crump (1912–1988). Hester was an active member of the Order of Eastern Star Celestial Chapter No. 38, the Chancellor Garden Club, the Sylvannah Home Extension Club, the Spotsylvania Historical Association, the Rappahannock Area Agency on Aging, and the Ladies Auxiliary for VFW No. 10546. (Courtesy Alfred C. Fairchild and family.)

When the day's and week's work was done, who could resist a party? Deborah Terrell (seated at left) was tasked with finding an entertainer for one of her civic groups. Here she conducts research in a local club. "Could this be the best singing draw to raise much-needed funds for us?" she thought. (Courtesy Deborah Terrell Smith.)

When Samuel Robinson was a boy, his family lost almost everything in the move to Spotsylvania from Caroline County so that the government could build an army training camp. He later married Pearl Gladys Alsop and fathered eight children. He and Pearl showed teenagers how to be independent through hard work. In her own kitchen, Pearl taught etiquette and home economics. Samuel provided carpentry, logging, and barbering apprenticeships. (Courtesy Shelby Robinson.)

Chester A. Quarles (1918–2005), the husband of Mary Fairchild, was a long-serving trustee of Beulah Baptist Church and the first African American ever appointed to the county's electoral board. This was not his first county-wide experience. He had previously served on the planning commission. (Courtesy Rosemary Quarles McKinney.)

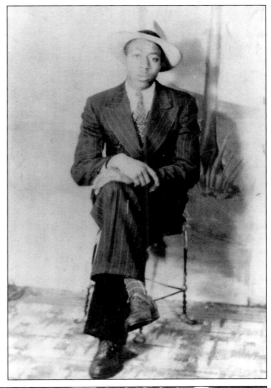

The son of Fred and Bessie Tyler and husband of Christine Braxton, Harry Tyler (left) retired from the U.S. Government Printing Office and was appointed to the county's planning commission, where he helped set policy for land development. When not working, fishing, or hunting, he rode the highways with his friend Albert Mercer, the baseball player with the legendary long first-base mitt. (Courtesy Peggy Tyler.)

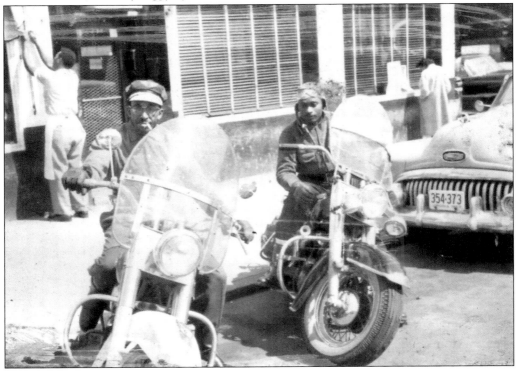

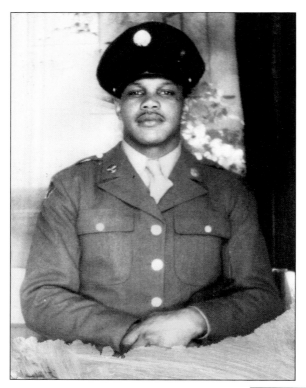

The son of Virgil and Ruth Wright Williams, Rudolph Williams was drafted into the air force in October 1943 while attending Hampton Normal and Agricultural Institute on a baseball scholarship. When he played for the Spotsylvania Yellow Jackets in 1947, he was the man with the killer fastball. His pitches were so quick and powerful that hitters were afraid to bat against him. (Courtesy Rudolph Williams.)

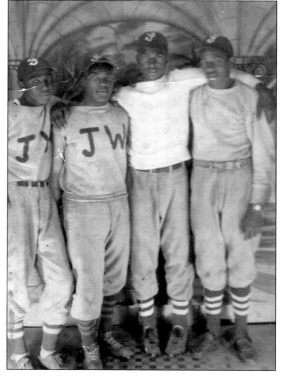

Baseball was both a pastime and a sport played at school. At the John J. Wright School, official uniforms were a small luxury, paid for mostly by contributions from parents. The players, however, could have competed later on any professional team. From left to right are Lenroy Williams, "Johnny Boy" Wright, Layton Fairchild, and Alton "Dick" Williams. (Courtesy Rudolph Williams.)

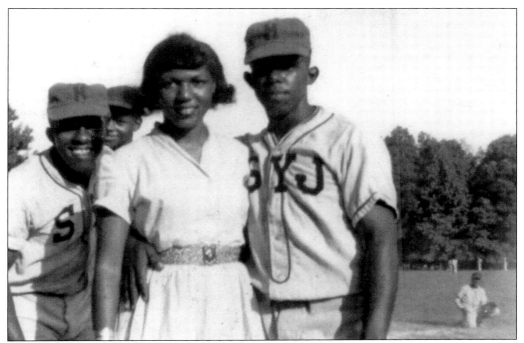

The sport continued after high school and developed into the Spotsylvania Yellow Jackets. Men used their own money to buy equipment simply for the love of meeting and traveling on weekends to play the game. Since baseball players were local heroes, who would not want a photograph? Pictured from left to right are Roger Lewis, Alfred Coleman, Ebby ?, and Roy Lewis. (Courtesy Alfred C. Fairchild and family.)

Boys were not the only ones who grabbed a bat at school or home. A girls' softball team was organized at school, and girls played after church in the backyard while still wearing their Sunday best. (Courtesy Clinton Braxton Jr.)

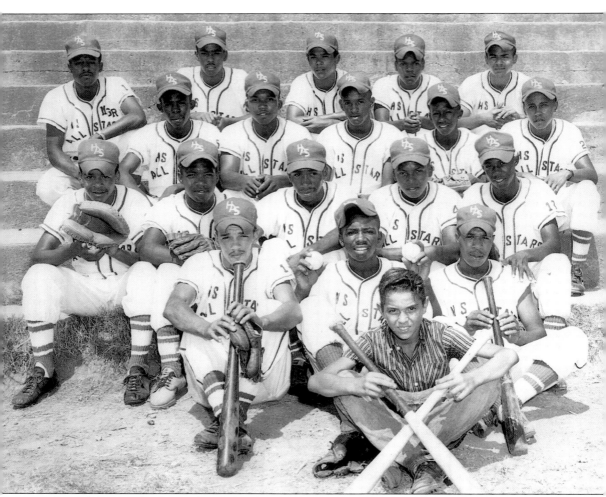

Spotsylvania's John J. Wright High School All Stars were established and managed by Charles "Sonny" Dyson in summer 1958. This was the first time black youth had an organized league with corporate sponsorships that paid for uniforms, equipment, and transportation. Shown here are the following, from left to right: (first row) Shorty Kay; (second row) Ralph Pierce, John Parker, and Leo Chapman; (third row) Robert Harris, Robert Beasley, Reginald Tyler, Squirrel Beasley, and Arthur Williams; (fourth row) Enos Moton, James Beasley, Dana Marshall, James Dyson, and James Young; (fifth row) manager Sonny Dyson, Willie Lee Parker, Paul Johnson, Nehemiah Catlett, and Albert Lee Johnson. (Courtesy James Dyson.)

Four

WITH OUR MINDS

Like other parts of the United States, formal education for African American children was outlawed in Spotsylvania County until after the Civil War. The first schools to emerge after the legalization catered to grades one through seven. They were one-room, uninsulated structures built largely and supported financially by community parents working through their churches. Black parents organized leagues where they met monthly to raise money that supplemented teachers' salaries and provided for building upkeep. The Virginia State Board of Education was responsible for certifying schools and issuing diplomas.

The Sunday School Union sowed the seeds of secondary education in the early 1900s. Land owned by the union was donated to build the Spotsylvania Training School, and much later in 1952, one-room school education was abolished with the subsequent opening of John J. Wright Consolidated School for African American children. Classes initially covered 1st to 11th grade, but 12th grade was added in 1958. Still, students graduating with an 11th-grade education competed and excelled against their 12th-grade peers from other institutions.

Previous publications have chronicled the county's education giants such as John J. Wright, Hazel Craft, and Sadie Combs Johnson, who was the first teacher chosen to work at the Spotsylvania Training School. Lesser known are those who did not have a chance to attend secondary school because they had to stay home and support their families. This chapter is dedicated to them.

Ethel Stratham Dandridge was the superintendent of all black one-room schools until John J. Wright Consolidated School was constructed. She then moved to the role of assistant principal—a post she held from 1951 to 1959. Her reputation for being relentlessly stern was tempered only by her desire to see every student perform at his absolute best and behave perfectly all the time. (Courtesy Alfred C. Fairchild and family.)

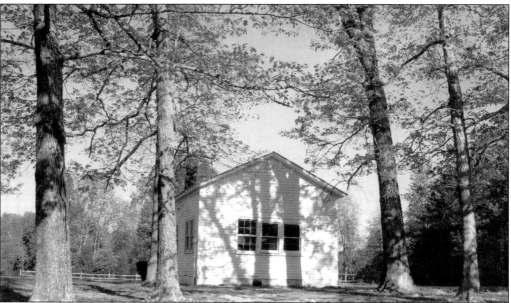

The Piney Branch School was erected around 1871, shortly before the adjacent church was built. Having a church on the grounds cultivated learning in a way that was unique. What was taught in church was reinforced in school and carried home to be practiced. When an important function such as a funeral occurred, school closed and the teacher brought children to participate. (Photograph by Terry Miller, April 2007.)

Teachers were among the most popular people in the county not only because they served the educational needs of children, but because they were educated, had jobs, and dressed well. As such, they had little problem finding dates or a mate. Shown here is Sara Minor, a teacher at school No. 9, also known as the Diggs School. (Courtesy Thelma Robinson Pryor estate.)

Parents fortunate to have enough money sent their children to the private Mayfield School at the far reaches of the county (now Fredericksburg). Understanding the need to encourage excellence, Reverend Ransom (center) acted as recruiter and mentor to ensure each student got a proper education. Two such students were Ollie Smith (seated far left) and Mary Byrd (seated second from right). Mary was born 1897 to James and Mary Byrd. (Courtesy Beatrice Byrd Lewis.)

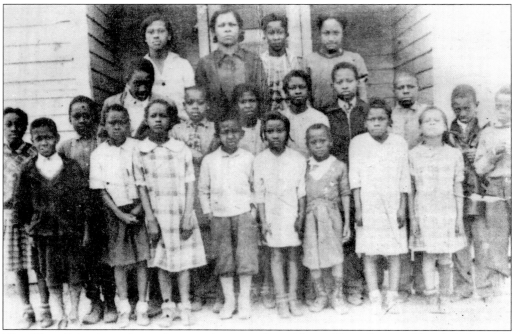

The Diggs School was located across the street from Mount Hope Baptist Church. This 1938 class included 9 boys and 12 girls taught by Isabell Redmond (third row, second from the left). (Courtesy Dorothy Smith Moore.)

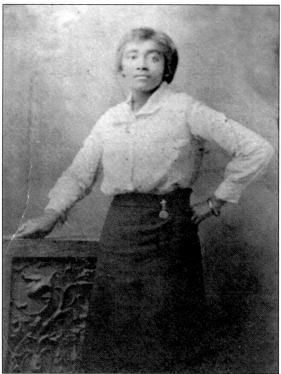

Otelia Upshur (1895–1935), the daughter of Tarleton and Eugenia Upshur, graduated from Virginia Seminary and College in Petersburg and became one of the first black teachers in Spotsylvania. She taught at Piney Branch School, married Albert Robinson, and, after bearing seven children, died in 1935 at just 39. Otelia's oldest daughter, age 14 at the time, sacrificed her schooling on her father's directive to tend to the family. (Courtesy Alberta Robinson.)

Dally Woolfolk Stanard (right) was a teacher at St. Paul's School. The daughter of Barney and Allie Robinson Woolfolk, she married widower Lawrence Stanard in 1928. Knowing how difficult life could be for their six children, she complimented them, encouraged them in their pursuits, and shared life lessons with them each day. When she died of complications from childbirth on July 1, 1943, it was heartbreaking for the children to go home from school knowing their mother would not be there. (Courtesy Christine Stanard Freeman.)

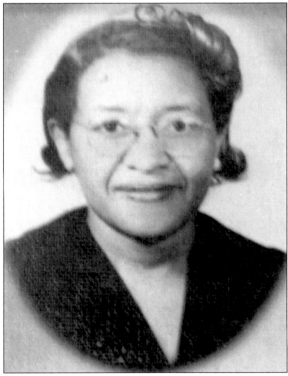

Rosa Cecelia White Dyson (1904–1966), the daughter of Henry and Nancy Diggs White, was one of the most popular teachers at the Piney Branch School. She was best known for her gentleness and constant encouragement. She married Charles Dyson in 1929 and had eight children. For 20 years after the Piney Branch School closed, Rosa taught whenever needed. (Courtesy Miriam Dyson Pendleton.)

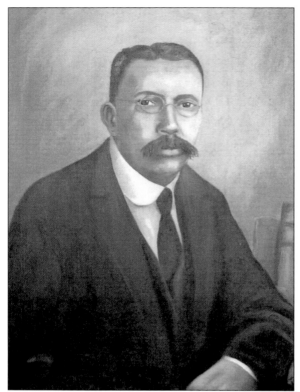

John J. Wright (1863–1931), the stepson of Woodson and son of Louisa Alsop Wright, was an 1894 honor graduate of Virginia Normal and Industrial Institute. Like many men of the time, he traveled north to work during the construction season and returned home during planting and harvest time. He advocated buying land and getting an education as paths toward independence. His major accomplishment was organizing the community to found the Spotsylvania Training School. The wooden, three-story school was designed and built over a period of nine years under the direction of Alfred "Allie" Fairchild. The building consisted of 4 classrooms on the main floor, 12 bedrooms for teachers and students upstairs, and 4 rooms, including a full kitchen, in the basement. The boarding cost was $7 monthly, and parents could pay in cash, food, or supply equivalents. (Left courtesy Lee Broughton; below courtesy Thelma Robinson Pryor estate.)

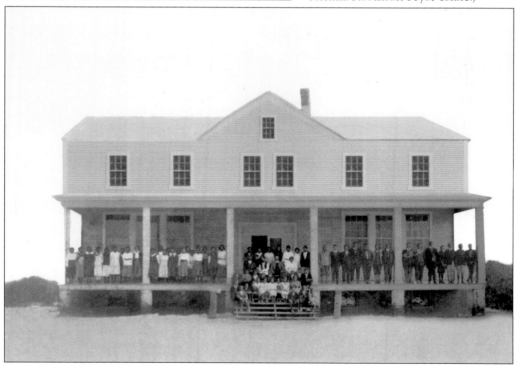

Lawrence Stanard was born about 1876 to Major and Addie Stanard. He wed Adell Davis in 1902, and after tuberculosis killed her, he married Dally Woolfolk. Active in the Sunday School Union, Lawrence was confronted by a white neighbor who asked him to speak out against building the Spotsylvania Training School. "I'll see what I can do," he replied. Seeing that his son was puzzled by that response, Lawrence said, "You don't have to tell them everything." (Courtesy Christine Stanard Freeman.)

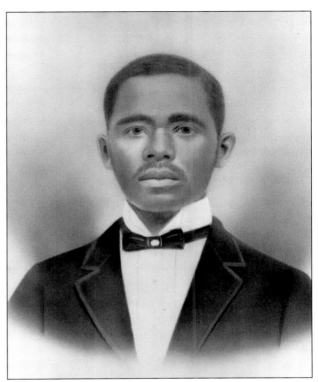

Nannie Washington Lewis supplemented her earnings from the Snell School by teaching sawmill workers rudimentary education. Born in 1907, she was the third child of John and Nettie Washington and grandchild of Elmo and Susanna Washington. In 1929, she married Preston Lewis. Within 10 years, Nannie had worn her body down to an early death, leaving her husband and two small children to mourn her memory. (Courtesy Tina Lewis.)

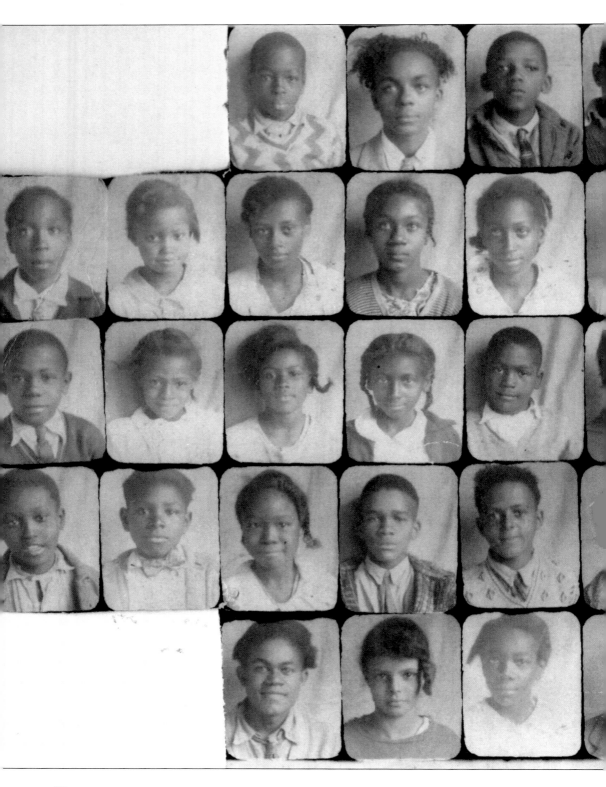

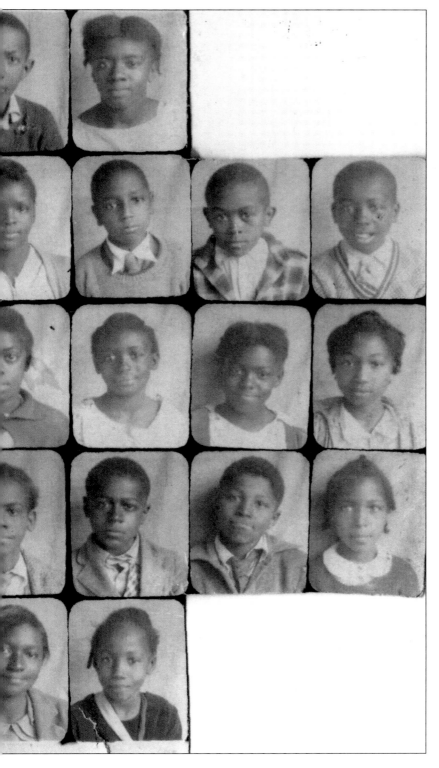

Once the county's one-room designated African American schools began to close, elementary-aged children full of promise either walked or rode a rickety bus to the Spotsylvania Training School. In this 1930 photograph, the youngest is six-year-old Edith Ellis (third row, second from the left). Both her brother Herman (second row, left) and her sister Violet (fourth row, third from the left) got all dressed up for school and walked to the road to wait for the bus. Their parents, Rev. Harry J. and Louise Jones Ellis, saw no reason why little Edith should stay home. They dressed Edith, and all three of the children got to ride the school bus. (Courtesy Edith Ellis Fairchild.)

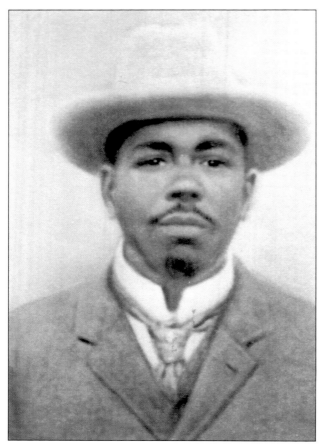

Archie Garnett (born around 1873) was the son of Archibald and Lettie Garnett. He cultivated his 15 acres, cooked at a local sawmill, and worked at the FMC plant. In 1933, Archie had a near-fatal heart attack and needed 24-hour care. His wife, Winnie, decided that their youngest daughter, Christine, would leave school in her last year to nurse him until Winnie could arrange to leave her job in Warrenton. Christine got the list of schoolbooks from next-door neighbor, classmate, and cousin Elnora Stanard, and Christine's father rode a horse and buggy to Fredericksburg to buy them. Christine returned to school in January 1935. In early March, her class was assigned William Cullen Bryant's *Thanatopsis*. Her father died a few weeks later, on the 28th, and Rev. Harry Ellis preached his eulogy, ending with Bryant's immortal words. (Courtesy Christine Garnett Chapman.)

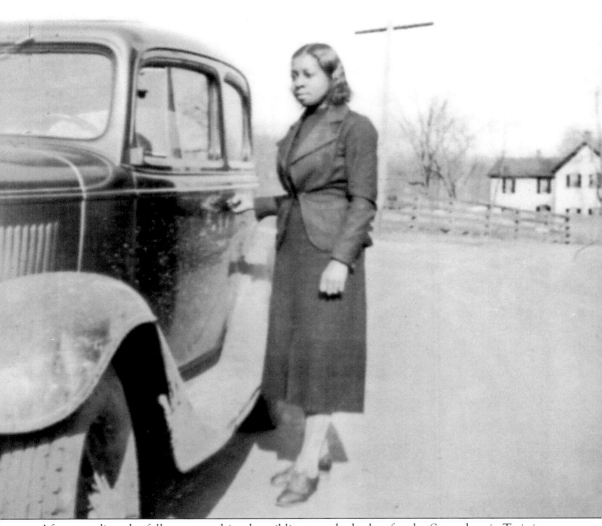

After spending the fall term watching her siblings catch the bus for the Spotsylvania Training School, Christine Garnett returned to the classroom in January 1935. She graduated in May, although it almost did not happen. Very near graduation, several men walked into the classroom where she was doing her work under the supervision of her teacher and principal, Owen Duncan. The men and Duncan were engaged in fervent conversation, and the children were all trying in vain to hear. The conversation was about Christine. They told Duncan that Christine could not graduate because she had no grades for the fall term. Duncan explained that she was home doing extensive self-study and caring for her father and that her grades had not suffered. The men refused to listen. They were insistent that she not graduate. Finally Duncan exclaimed, "She *has* to graduate. She's the valedictorian." (Courtesy Christine Garnett Chapman.)

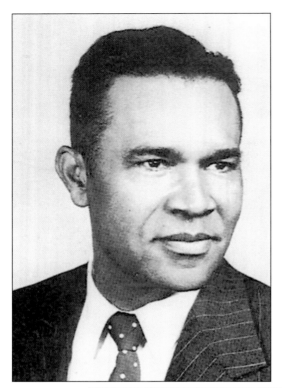

Alexander Livingston Scott (1904–1981) became principal of the Spotsylvania Training School in 1936. Born in North Carolina, he graduated from Hampton Institute and Cornell University. In his job as principal, he showed quiet authority. Nobody wanted to go to the principal after seeing assistant principal Ethel Dandridge. The look on Scott's face was enough to make one want to crawl from the room. Yet there was a softer side, evident in his autograph to graduating student Christine Braxton (below). He relinquished his position at John J. Wright in 1959 to accept a position in Charlottesville. (Left courtesy 1958 John J. Wright yearbook; below courtesy Peggy Tyler.)

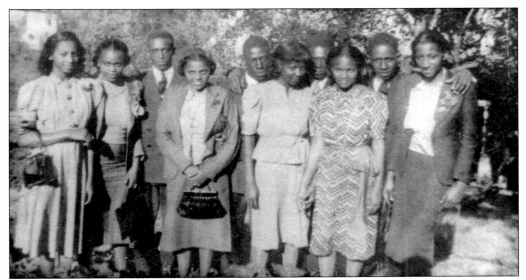

While on their senior trip, some members of the 1939 graduating class stop to pose for the camera. Shown from left to right are Annie Crump, Edith Coleman, Hollis Terrell, Christine Broadus, Bedell Coleman, Meredith Terrell, Marshall Gibson, Lillian Robinson, Herbert Clark, and Audrey Lee Braxton. (Courtesy Lillian Robinson Pryde.)

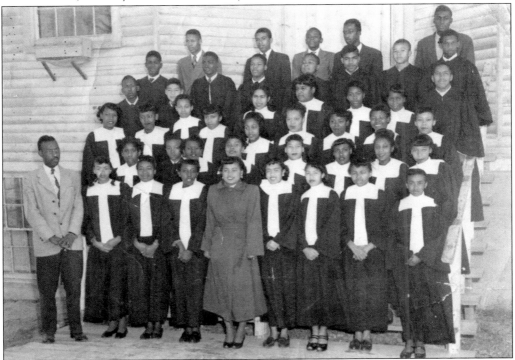

Philip Bates (far left) was a specialist in music and English who was also responsible for the purchase of Spotsylvania Training School's organ. A masterful musician and teacher, he trained the voices of many students into a soul-stirring choir, and his English classes were legendary for their depth and attention to critical writing. (Courtesy Alfred Fairchild and family.)

One day on the long school bus ride home, E. Earl Hart (1931–1947), the son of Ernest and Edith Hart, buckled over in pain. As he was unable to walk once off the bus, friends ran to Earl's house and got his father, who then rushed him to the hospital, where doctors determined that he had spinal meningitis. Earl died that cold February night at only 15 years of age. (Courtesy Lillian Hart Brooks.)

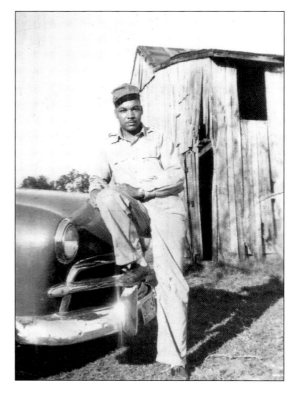

Beginning his 19-year career at John J. Wright in 1949 as a vocational and agricultural teacher, Pitman C. Rock Sr. advanced to guidance counselor, assistant principal, and then principal. He retired from education in 1978 and died on July 4, 1989. (Courtesy Beatrice Byrd Lewis.)

The daughter of Clayborn and Laura Willis and wife of Joseph Lewis, Elnora Lewis (born in 1898) was taught by John J. Wright at the local one-room school on Route 1 in the early 1900s. She grew to become a teacher herself—at the Summit School near Second New Hope Church until 1952 and then at the newly constructed consolidated school. (Courtesy Constance Braxton.)

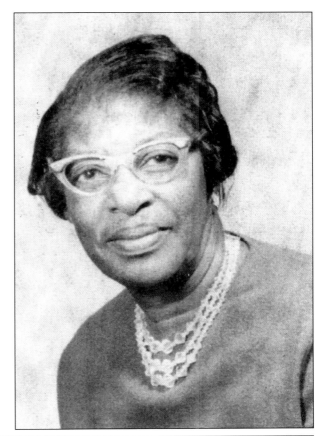

After the destruction of the Snell School by fire in 1941, tremendous pride was exhibited when one-room education was reformed and the brick school was constructed and opened to all African American students. Its new name was the John J. Wright Consolidated School, and its average enrollment from 1952 to the year before integration in 1964 was 866. (Courtesy 1958 John J. Wright yearbook.)

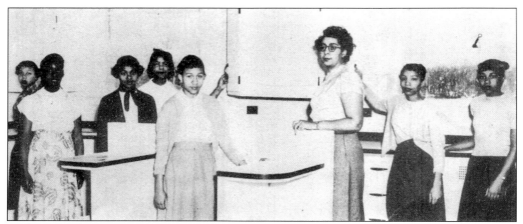

Carlean Bumbrey leads her home economics class in 1952. Girls were taught the necessary skills of rural communities: etiquette, cake baking, cleaning, sewing, and hygiene. (Courtesy 1952 John J. Wright yearbook.)

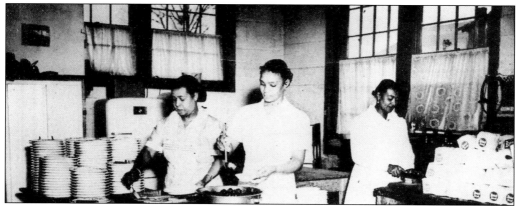

Home cooking was what students received from the kitchen staff at John J. Wright, but real treats were had when they served ice cream or chocolate milk. (Courtesy 1952 John J. Wright yearbook.)

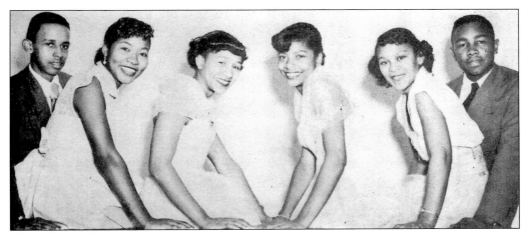

It was always a happy day when Miss Spotsylvania and her court were announced. Seen in 1952 from left to right are Thomas Brooks; Gillete Wormley; Edith Coleman; Miss Spotsylvania, Audrey Crump; Velma Ferguson; and Leon Hart. (Courtesy 1952 John J. Wright yearbook.)

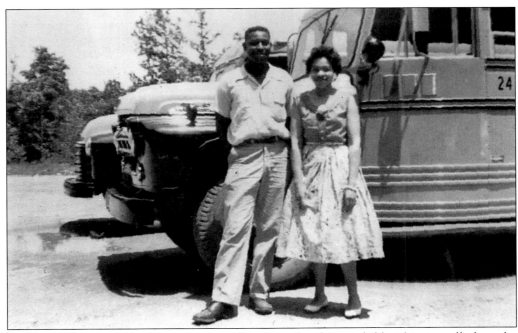

William H. Poindexter knew every corner of the school and every child within its walls, how the school operated, and how to maintain order. Working first for four years as part-time custodian at Beaumont, he was appointed head custodian at John J. Wright. He is pictured here with Zelda Coghill. (Courtesy Clinton Braxton Jr.)

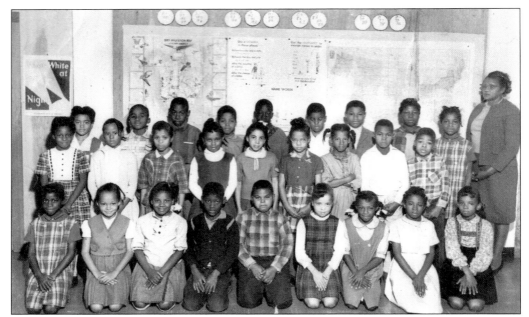

One of the most demanding yet revered teachers was Thelma Pryor, who insisted on maintaining high academic standards. She preferred teaching elementary children in order to start them out well. The grading scale started at 100 points for an A+ and progressed downward to 75 points for a D-. Failure began at 74 points and was simply not an option. (Courtesy Thelma Robinson Pryor estate.)

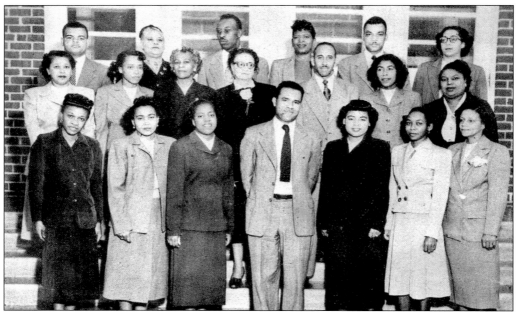

Led by principal Alexander Scott (center front), the teachers of John J. Wright Consolidated School made students feel wealthy with their sense of caring, even though they did not have all the necessary materials with which to work. Although students did not realize it, the marks of each teacher were the life lessons they shared. (Courtesy 1958 John J. Wright yearbook.)

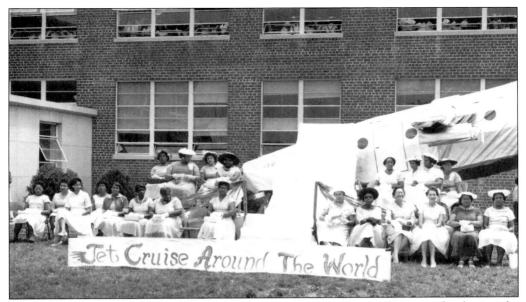

Teachers and parents organized a virtual jet cruise on May Day in 1959 as a fund-raiser for John J. Wright School. Supporters dressed up, paid a fee, left the luggage at home, and flew around the world in their imaginations. (Courtesy Beatrice Smith and Dorothy Smith Moore.)

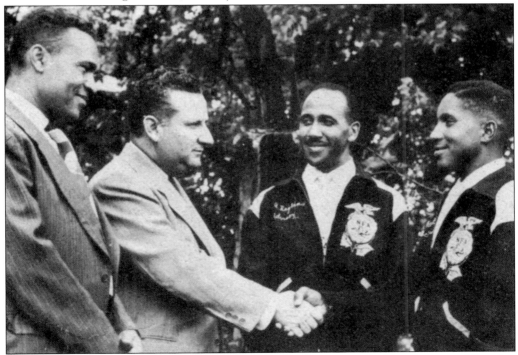

John J. Wright student Arthur Burnette (far right) won first prize in the New Farmers of America quiz contest held in Atlanta, Georgia. Here he receives congratulations from C. Melvin Snow, superintendent of Spotsylvania schools, as principal Alexander Scott (far left) looks on. (Courtesy 1952 John J. Wright yearbook.)

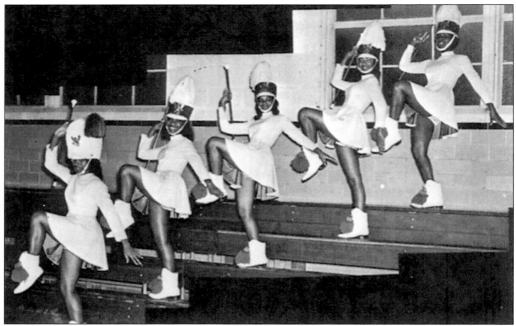

Trained and managed by physical education teacher Courtney Sample, the John J. Wright Majorettes were known for high-stepping precision routines. Pictured from left to right are Louise Williams, Brenda Lawson, Sheila Sample, Edith Cook, and Sharon Mercer. (Courtesy 1964 John J. Wright yearbook.)

Through literature, eighth-grade teacher Rosa Ware opened a world within Constance Braxton, the daughter of Clinton Sr. and Elnora Stanard Braxton. *The Canterbury Tales* and *Silas Marner* instilled a passion for reading that propelled her through college, postgraduate studies, her first teaching position in 1963, her appointment to assistant principal in 1979, and finally to a promotion to principal. Constance was the first African American after integration to hold that position. (Courtesy Constance Braxton.)

Five

IN OUR ARMS

We deeply yearn, mistily dream, but cannot hold in our arms forever those we cherish. In this chapter, tribute is largely paid to ancestors—and in some cases the items they owned—that loom in recent memory. Fashion, friendship, and emotions are themes represented throughout these pages. One cannot help but make comparisons with the manner in which these, our nearest relatives, left their mark on current behaviors.

Last, we honor some who served in different branches of the military through various wars. For many, it was their only opportunity for a life bigger and better than they could have had if they remained in Spotsylvania. Their legacy is one of discipline and accomplishment.

This chapter is dedicated to small acts of kindness, tears cried when no one else is around, love letters wrapped in string in an old drawer, and anyone who suffers the memory of someone's life that was cut too short.

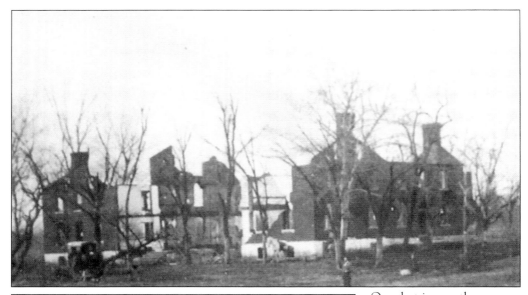

On what is now the corner of Route 3 and Ely's Ford Road, the epic and bloody Battle of Chancellorsville raged around the once-opulent property where Hester Lewis (c. 1851–c. 1925) lived and worked as a young girl. After the battle, she and one of the owners came out of the basement and left, stepping over dead bodies that were two and three deep. Hester went on to marry Charles Hughlett, who provided well for the family. Her health failed after he died of a heart attack while planting corn in his field, and she moved in with her daughter Mary and son-in-law Rev. Thomas Ross. Shortly after Charles's death, Hester fell and broke her hip. It became infected, and she never recovered. (Above courtesy Chancellor Historic Marker, photograph by Terry Miller, May 2007; left courtesy Doris H. Barnett.)

In the days when it was traditional to have large families, William Terrell (born in 1849) and his wife, Rachel (born in 1858), had 11 children. The Terrells exemplified the families that asked for little, wasted nothing, and gave all they had to their church. (Courtesy Rev. Gilbert Garcia and First New Hope Baptist Church archives.)

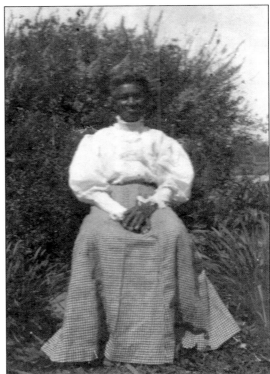

Born around 1840 and married to William Parker in 1872, Sophronia Stanard Parker emerged from slavery with her wits intact and survival lessons learned. One simple lesson was how to use what was available to satisfy hunger. She would lay flattened dough between a bed of ashes in the fireplace and, when it was just right, remove it, slice it, and fill it with fruit preserves. (Courtesy Beatrice Byrd Lewis.)

Before her name was Fannie Camack (c. 1855–1920), she was a full-blooded Cherokee Indian who was sold into slavery from Georgia and ended up in Spotsylvania working on the Morton farm near what is now Alsop Town Road, where she met and married Fred Banks. A child during the Civil War, Fannie hid in a fruit cellar whenever she heard soldiers riding on their horses. (Courtesy Roganna Howard Rollins.)

The son of Emaline Minor Byrd, Lemuel Byrd (born around 1856) married Addie Acors, the daughter of Thomas and Melinda Acors, on December 21, 1885. When Lemuel was a widower, his son-in-law tried to take his 38 acres; Lemuel defended his property with the threat of an ax. Within days, he was forcibly sent to live the rest of his life in a Petersburg institution on the false charge that he was mentally unstable. His daughter later bought his property at auction. (Courtesy Doris Hughlett Barnett.)

John Townes and his grandson Lewis (right) moved into Fannie Howard's boardinghouse after John forcibly left an unhappy marriage to Annie Carter, the daughter of Abram and Mercury Camp Carter. When John died, his grandson was taken under the foster care of Fannie Howard. Sad and lonely, Lewis (below) acted out his unhappiness in a variety of progressively damaging ways. One day when he was about 15 years old, his foster mother could not find him. She searched for hours and then, in a fit of desperation, lifted the lid from a barrel and found him asleep and intoxicated. She took the difficult step of contacting his birth mother, who made the heart-wrenching decision to send him to the famous Boystown Orphanage in Nebraska. (Courtesy Roganna Howard Rollins.)

Louisa Alsop was born into slavery on the Blanton farm about 1842 to unnamed parents and went on to work in "the big house." Louisa represents all young women of the time who kept their dignity through the difficulty of having children alone, yet caring and protecting them as best they could. She named her second child John Julian and eventually met and married Woodson Wright. Louisa's previously born children and all products of this union were known, raised, and nurtured under the surname Wright. (Courtesy Rudolph Williams.)

Rites of passage sometimes involve different ways to be a man. Charles Howard (born in 1874), the son of Constance and Melvina Howard, was known for his powerful temper. He usually won every fight in which he engaged because he grabbed his adversary and butted him with his head. The sheer force of his actions often knocked his opponents immediately to the ground. (Courtesy Melvin Thompson and family.)

Dossie Moss, the daughter of Kellis and Hardenia Moss, was born on April 16, 1882. Growing up and marrying Abner Wigglesworth in 1907, she soon found that this particular marriage was not a positive one. Divorced, she raised the couple's two children and earned a living by farming and doing housework. Dossie's biggest enjoyment, though, came from growing and showing peonies in her favorite color: pink. (Courtesy Marian Moss Green.)

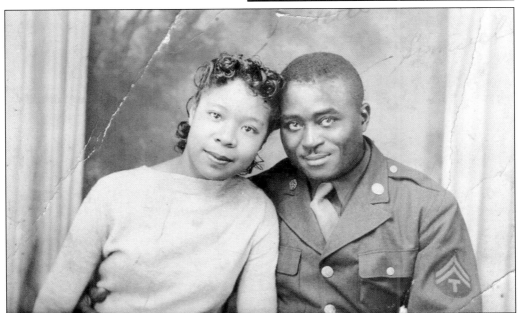

"Please do not tell Mom I have a boyfriend," says this look by Violet Ellis, pictured with her soon-to-be-husband, Samuel Bell. Violet (1921–2007) was the daughter of Rev. Harry and Louise Jones Ellis. She met Samuel at the famous Wayside Inn, known for having one way in and one way out. (Courtesy Edith Ellis Fairchild.)

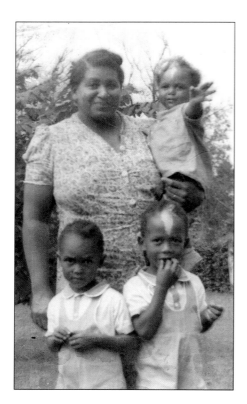

Aunts give different kinds of attention than parents. In 1940, Lovey Jackson holds her nephew Elmo McKinley Cook while two of his three brothers, Benny Hansbury (left) and James Matthew, look on. There are both visible and invisible birthmarks within families, and the special signature of this family appears on the boys' foreheads. (Courtesy Elmo McKinley Cook.)

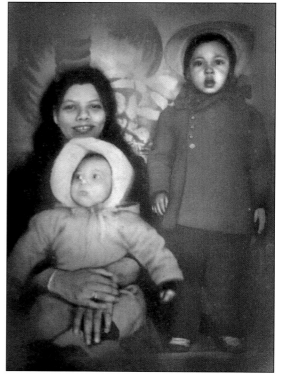

One of the daughters of Alfred and Rosa Fairchild, Mary Fairchild (born in 1920) had a joy throughout her life that was contagious. When she married Chester Quarles and had children, motherhood brought forth even more of her gracious and loving qualities. The greatest gift she gave her children was letting them know every day of her life that she loved them unconditionally. Mary is shown here with two of her children, Joan and baby Rosemary. (Courtesy Rosemary Quarles McKinney.)

Margaret Lewis (1900–1997) was the daughter of James and Eliza Lewis. She played dress up as a little girl and worked as a hotel chambermaid when she married taxi driver John L. Hevelow in 1928. She did not need to play anymore. She simply loved fashion, wearing high heels well into her 90s. (Courtesy E. Jean Lewis.)

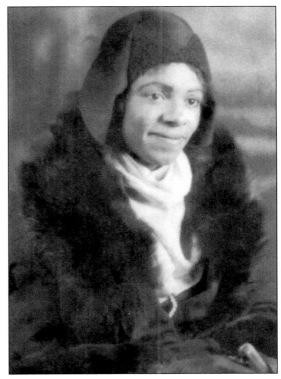

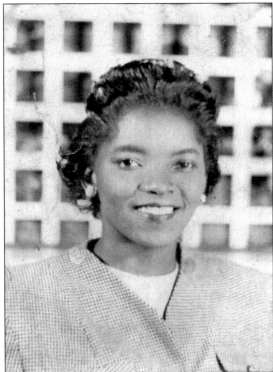

Letting nothing keep her from finishing a project, Naomi Robinson Mills (1925–1985) used perseverance until the answer to her request was "yes." The youngest daughter of Albert and Otelia Robinson, she worked for the National Labor Relations Board for 30 years and financially supported her Piney Branch home church as president of its Washington Club. (Courtesy Narcissus Robinson.)

Daughters of farmer Thomas Calvin (1890–1973) and Susan Upshur Lewis (1896–1992), Eliza "Dutch" (left) and Mary show sister love at their home place in May 1947. (Courtesy Barbara Lewis.)

In 1950, brothers Mahlon (left) and Thaddeus (right) Robinson, with a cousin, visited their father's home place in Spotsylvania from California. They fell asleep one evening while waiting for their father, Albert Nathaniel (born in 1919), to come home. A late knock on the door on March 14 told them that he had been in a fatal car accident. After the burial at Piney Branch Cemetery, the boys left with their mother and never returned. (Courtesy Alberta Robinson.)

John Roy Washington (born in 1874) was a divorced father of seven when he married his single-parent housekeeper, Cora "Cauley" Smith (born around 1903), the daughter of Eliza Smith. Here he stands with his granddaughter Jeanette, the daughter of his youngest son, Garnett. John, whose hair turned white early, is remembered as protective, appropriately strict, and always loving. (Courtesy Vivian Lee Washington Brooks.)

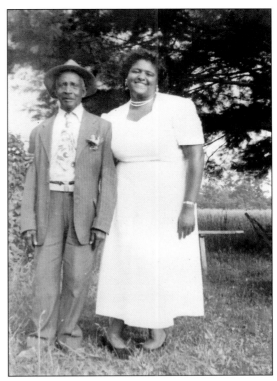

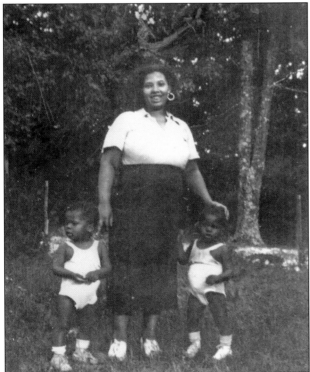

Mary Elizabeth Banks McCall (1914–1973) was the daughter of Susie Brown Banks, wife of Sidney McCall (1891–1965), and mother of nine. She once took her twin sons to the Newberry store in downtown Fredericksburg. At one point, Mary heard a voice admonishing, "Hurry up. Come on. Mama is looking for you." She turned around to see that it was Richard talking into a mirror, thinking the reflection was his twin, Robert. (Courtesy Richard McCall.)

On a warm June 1957 evening at 6:20 p.m., a mother and two daughters walked about 100 yards from their home on Route 208. The mother was making a way for the girls to walk through the brush on a high bank of the road when she heard an urgent screech. She turned to see a lumber truck sliding on its side toward her and an embankment. When the truck stopped almost 90 yards up the road, her two girls—Carolyn, age five, (left) and Mary, age four (below)—had been hit and killed instantly. According to the police report, the girls darted into the curved road, answering the call of a friend across the way. The truck driver swerved and could not stop fast enough. Their mother, Margaret Fauntleroy, remembers the playful Mary not wanting to have her hair combed. "When I die and be born again," she often said, "I'll have straight hair." Carolyn did not like to pose for photographs. It is joyous to her mother that she is forever immortalized in this one photograph, taken at the Snell School. (Courtesy Margaret Williams Fauntleroy.)

Seeing bounded grief on Margaret Fauntleroy's face as she stood over the graves of her two young daughters, Mamie Washington Braxton (born in 1926) walked over and gently took Margaret's 18-month-old child from her arms so that she could mourn freely. Known for her uncommon acts of kindness, Mamie was the daughter of Earl and Ruth Washington, wife of Roger Braxton Sr., and mother of four sons and one daughter. (Courtesy Ruth Lewis Wood.)

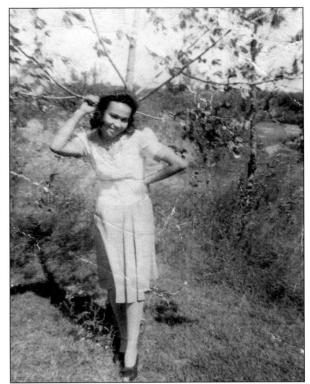

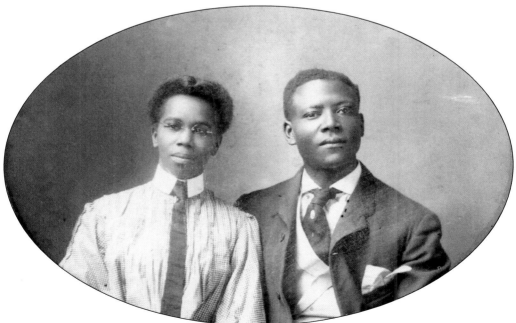

Extended family members are precious, especially when they step in and care for nieces and nephews. Robert and Sophronia Byrd Upshur helped raise Sophronia's brother Floyd's children when his wife, Nina Pryor Byrd, died of tuberculosis in 1930. (Courtesy Beatrice Byrd Lewis.)

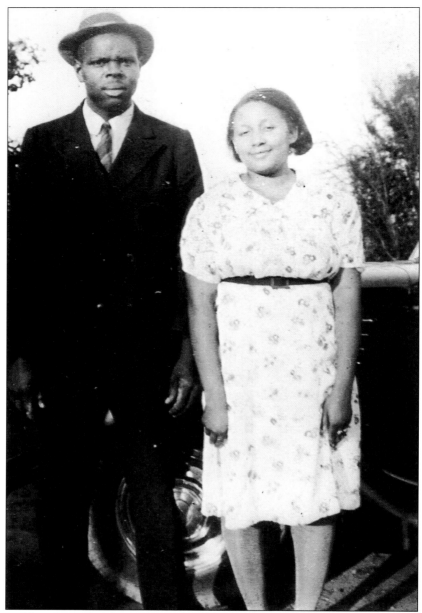

On their wedding day—October 21, 1940—George Taylor (born in 1919) and Alice Jackson (born in 1923) pose for an official photograph. George was the son of Frank and Lola Taylor, and Alice was the daughter of Clayborn and Lottie Gordon Jackson. Not having anything appropriate to wear, George went to his brother Frank Jr. and said, "Hey, I'm getting married today and I need a suit." Frank was shorter than George, but the suit worked for the occasion. Becoming sentimental about his marriage, however, George decided to keep Frank's suit. George worked on electrical wiring at Lake Anna. One day, a plane from the local airport took off on a sightseeing tour when the pilot noticed something unusual and called the rescue squad. Rescuers found George's body next to a power line. He had died from a heart attack. Six months and six days later, Alice died as well. The year was 1978. (Courtesy Sylvia Taylor Boone.)

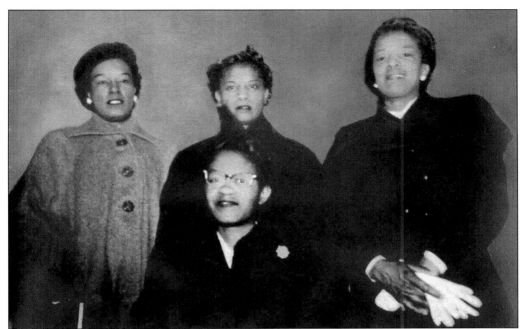

Edgar and Lena Smith's four daughters always dreamed of returning to their home place and living the remainder of their lives together. While all of them cannot be present in body, their spirits are indeed there. Pictured from left to right are Lillian Smith Watts (1922–1980); Sylvia, the oldest (1915–1970); Dorothy Smith Moore (seated); and Beatrice. (Courtesy Beatrice Smith and Dorothy Smith Moore.)

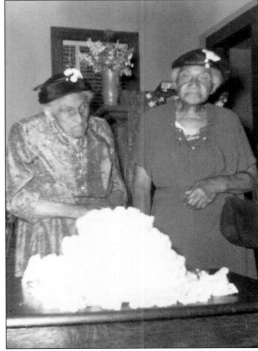

Emma Jackson Gibson (1858–1961) and her sister Anabelle Jackson celebrate Emma's 100th birthday. As children, they lived on the Whitehall Farm, where mining occurred. Both remembered the sound of bugles and distant gunfire during the Civil War. Emma recalled the day Union soldiers raided the farm for food. She married Thomas Gibson in 1881, gave birth to six children, and farmed and lived off the family land. (Courtesy Lillian Banks Cottoms.)

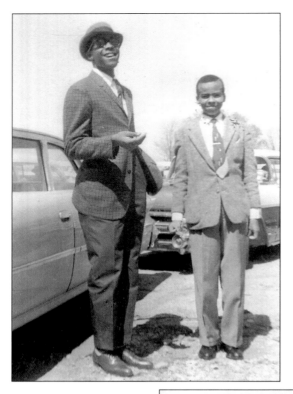

Washington Woolen Mills was the only department store where African Americans could purchase high-quality clothing, be treated with respect, and secure credit. Roger Braxton (left) earned $50 monthly driving the school bus and used his earnings to buy Florsheim shoes, a tan, black, and olive-green sports coat, and a stingy brim Stetson hat. His brother Sam's suit did not come from Washington Woolen Mills—he was not old enough to shop there. (Courtesy Roger Braxton.)

Church tradition mandated that when a member died women wore a black dress and veil and men wore a black-heart patch on their right sleeve. Here Albert Mack Alsop, the son of Mack (1892–1929) and Irene Gordon Alsop (1892–1979), pays tribute. Someone would soon be paying their last respects to him, as he had epilepsy and died in 1949. (Courtesy Gloria Alsop Carter.)

Marie Alsop was born in 1916 to Mack and Irene Gordon Alsop. In 1927, she married Rufus Brooks (1903–1986), the son of Boas and Mary Brooks, and had 22 children, including two sets of twins. Even though life was difficult, Marie always made it special for her children with a big breakfast every morning and a hearty Sunday dinner of fried chicken, cabbage with potatoes, and applesauce with biscuits. (Courtesy Josephine Brooks Ellis.)

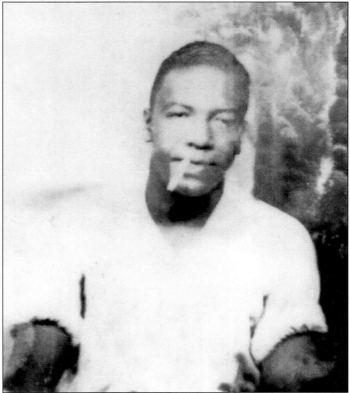

Christopher Columbus Alsop was born in 1925 to Mack and Irene Gordon Alsop. One week after visiting his sister and newborn niece in 1947, he and a contentious buddy left the Oak Lodge and walked along Route 1. Christopher was pushed by the other man into the path of a moving car and fatally wounded. In the driver's sorrow, he paid the burial expenses. Christopher was 23 years old. (Courtesy Landonia Alsop Taylor.)

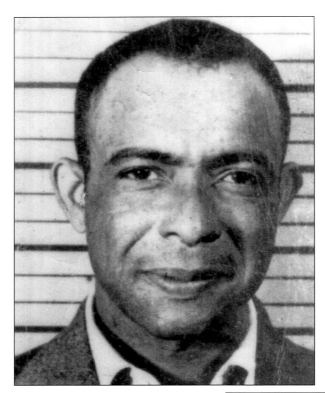

Born in 1915, Aurelious Gratton Pryor was the oldest child of Aaron Thomas and Julia Lee Pryor. He later married Thelma Robinson. The father of three sons under 10 years old, he was the victim of a fatal car accident on a cold, icy December 29, 1950. (Courtesy Thelma Robinson Pryor estate.)

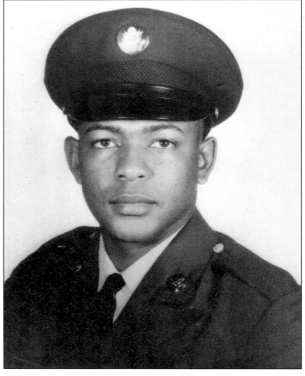

The second son of A. Gratton and Thelma Robinson Pryor, Aurelious Geraldo Pryor (born in 1944) came home for the holidays in 1968. It was Christmas Day, and he had already had a full day of making the rounds to family and friends with just a few more visits to go. He did not make it. Like his father 18 years before, Aurelious was killed instantly in a nighttime car accident. (Courtesy Thelma Robinson Pryor estate.)

118

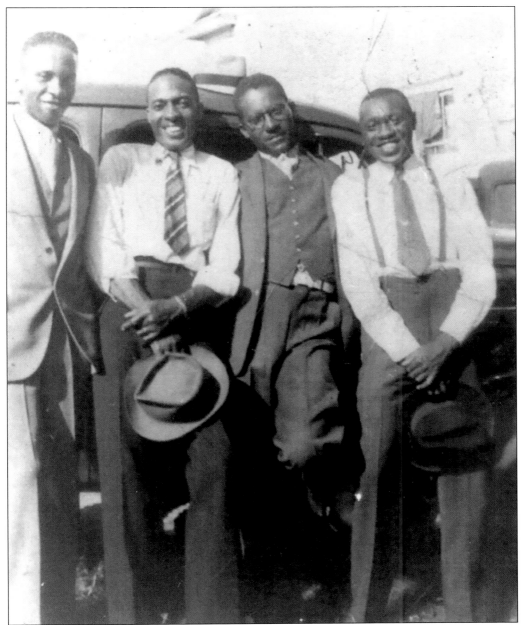

There is nothing quite like the friendship between men that was developed through childhood. Each of the men pictured here started his own life working on his grandfather's farm. And as they got older, all worked in blue-collar jobs and learned from their fathers how and when to dress for special occasions. The most special was church. Here in the early 1930s are brothers in two families: the Braxtons and Tylers. Pictured from left to right are Clinton Braxton (October 15, 1910–June 26, 1981); Alvin Spottswood Tyler (March 16, 1916–October 10, 1967); Irvin Braxton (June 1, 1909–January 13, 1978); and Medwyn Tyler, born on March 18, 1913, and killed in a devastating department explosion at the FMC plant on June 17, 1934. (Courtesy Rhonda Fortune.)

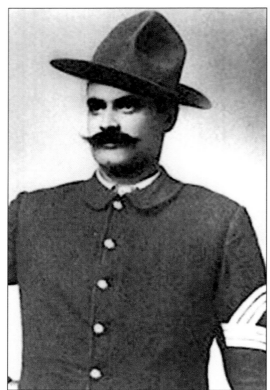

U.S. Army sergeant Benjamin Brown (1859–1910) was the son of Henry and Polly Brown and a Buffalo Soldier assigned to Company C of the 24th U.S. Infantry. On May 11, 1889, while accompanying a stagecoach through Arizona transporting the army payroll, the company was attacked by bandits. Even though he was wounded, Sergeant Brown continued to fight. He received the Congressional Medal of Honor on February 19, 1890. (Courtesy National Park Service.)

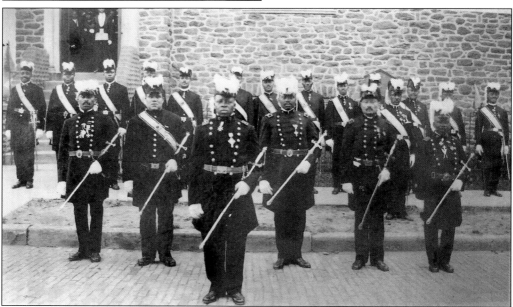

These World War I soldiers have donned dress uniforms for a formal ceremony. Front and center is William Howard Terrell (born in 1892), the son of Lewis and Rosa Terrell. When he entered World War I, he was a dockworker in Philadelphia, the place he chose when suitable employment at home was not available. (Courtesy Deborah Terrell Smith.)

World War II veteran Benny Carter, the son of Robert and Birdie Johnson Carter and husband of the former Juanita Acors, was a multitalented fireman, carpenter, and chef. Standing still, he would motion with his index finger in a slow, clockwise direction and share various thoughts that would always come true. One time, he told his brother-in-law Charles Terrell about a man in a white robe covered in water. Two months later, that man was Charles Terrell being baptized. (Courtesy Gladys Carter Cook.)

Master carpenter Alfred C. "Dadie" Fairchild was born in 1918 to Alfred and Rosa Fairchild. He spent all of his early years working with his father before being drafted into the U.S. Army, where he was an ammunitions runner. He gave unselfishly his time, talent, and treasure to his church and neighbors. Most noteworthy are the lessons he still imparts. "It's not what you earn, it's what you save," he says. (Courtesy Alfred C. Fairchild and family.)

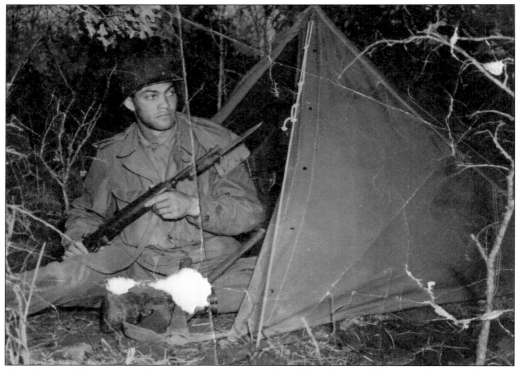

The Korean War produced men of uncommon valor. Here Leroy Miller is on lookout during a scouting expedition. He earned high honors while in the war and was honorably discharged. (Courtesy Brenda Terrell.)

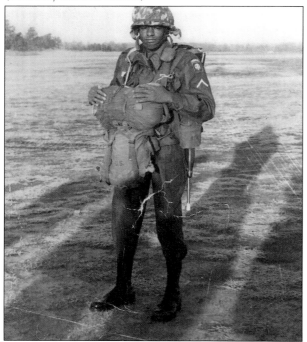

Sgt. Charles E. Dyson Jr. was a former mounted policeman, an active reservist and career soldier, and a member of the 1st Cavalry Division. Deployed to Vietnam in December 1965, he was attacked by enemy fire in February and became the first area resident to die in that war. He was 31. Dyson wrote the *Free-Lance Star* shortly after his arrival in Vietnam and foretold, "The bullets are real and the price is life." (Courtesy James Dyson.)

EPILOGUE

Societies are comprised of all types of people in all types of situations. The success of the society is seen in how it treats the least of its residents. Six men and women were asked to share their thoughts because their wisdom is needed when life's hurdles seem to have no answers. The question posed to them was simply this: What lesson do you want people to know? In their own words are Layton Fairchild Sr., Lillian Robinson Pryde, Booker T. Ross, Alberta Robinson, Benjamin Fletcher, and Vivian Lee Washington Brooks.

We first dedicate this epilogue to the memory of men and women whose lives were never easy and who scraped day by day just to eat. We honor all those through the years whom we passed by regularly without acknowledging because their clothes were a little dirtier, their hair a little knottier, and their smell a little fouler. Last, we dedicate this epilogue to Thelma Robinson Pryor, who, were she alive, would have relished sharing her thoughts with us. She would have challenged each of us to cultivate the best thoughts, nourish the best spirits, reach the best inner peace, strive for the best academic achievement, and be the best chroniclers of our collective past, present, and future.

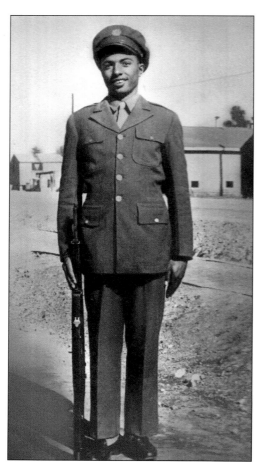

"I never saw real hunger and poverty until I was in the service over in Japan and saw children and adults eating out of the garbage can after we scraped our plates. We have opportunity in this country and there needs to be sacrifice in order to earn things. You have to want more for yourself than you can see and then have the discipline to work for it honestly," states Layton R. Fairchild Sr. (Courtesy Layton R. Fairchild Sr.)

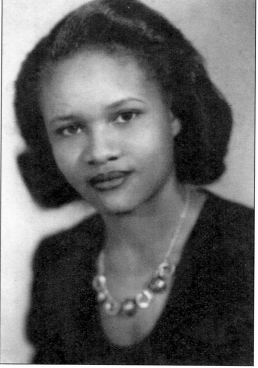

"You are one of the Great Creator's handiworks with a special purpose designed only for you. You were given the ability to discern the good from the bad. You must have the wisdom to choose the good, move on to accomplish that purpose, and accept the present challenges without personal vanity. You must persevere!" implores Lillian Robinson Pryde. (Courtesy Lillian Robinson Pryde.)

According to Booker T. Ross (seated far right), "When I was coming up, baseball was how we learned a lot of things: teamwork, negotiation, how to use your mind against the other guy, and just the skill of the sport. If we could get young people interested in that again on the local level, there's no stopping what they can do." (Courtesy Booker T. Ross.)

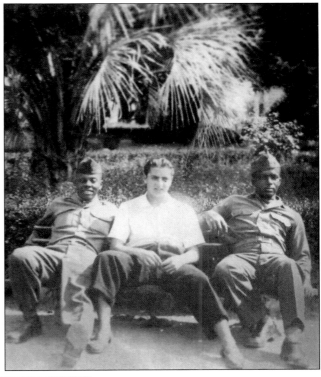

"We would do a lot better if we followed a basic teaching: to be obedient to God's word. I remember as a child when we did not have much to give, but we gave all that we had and it came back to us in abundance. It's the same today. If we give freely of ourselves and are obedient and faithful to the things that are of God, we will prosper," says Alberta Robinson. (Courtesy Alberta Robinson.)

According to Benjamin Warren Fletcher, "We are trying to build a world within a world and as such we are failing from lack of knowledge. There are people within our community who have capabilities but will not give us the knowledge to survive. That must change or we will continue to go backwards rather than forward." (Courtesy Benjamin Warren Fletcher.)

"The purpose of an education is to reach out, raise understanding, and share with those who don't know. Remember that if it had not been for the Lord who gave you the power to understand, you would have nothing. If there was no 'before,' there can be no 'after,' so never get so high, mighty, and powerful that you forget your ancestors," states Vivian L. W. Brooks. (Courtesy Vivian L. W. Brooks.)

Selected Bibliography

In addition to more than 500 personal interviews, copies of the *Free-Lance Star* since its inception, and anniversary booklets for each of the 12 original churches in the Spotsylvania Sunday School Union, the following primary and secondary sources were used most often.

Adelman, G. E., and J. J. Richter. 99 *Historic Images of Fredericksburg and Spotsylvania Civil War Sites*. Gettysburg, PA: Center for Civil War Photography, 2004.

Durrett, Virginia Wright. *Marye: Past and Present*. Spotsylvania County, VA: Cardinal Press, 2003.

Fitzgerald, R. C. *A Different Story: A Black History of Fredericksburg, Stafford, and Spotsylvania*. Fredericksburg, VA: Unicorn Publishing, 1979.

Flippo, P. V. C. *A Biography of the Homer J. & Mary E. Combs Family: They Bring the Past to Life*. Spotsylvania, VA: self-published.

Gallagher, G. W. *The Battle of Chancellorsville*. Washington, D.C.: National Park Service, 1995.

Lea, R. F. *The "Belfield" Fitzpatricks and "Elim" Colemans: Their History and Genealogy*. Self-published, 1954.

Mansfield, J. R. *A History of Early Spotsylvania*. Spotsylvania, VA: Spotsylvania County Board of Supervisors, 1977.

Spotsylvania County deed books

Spotsylvania County land books

Spotsylvania County Marriage Record Nos. 1, 2, and 3

Spotsylvania County settlements books

Spotsylvania County will books

Stafford, L., P. Flippo, and E. Monroe, eds. *Freedom of Worship: A Religious History of Spotsylvania County 1767–1976*. Spotsylvania, VA: Religious Heritage Committee, 1976.

DISCOVER THOUSANDS OF LOCAL HISTORY BOOKS
FEATURING MILLIONS OF VINTAGE IMAGES

Arcadia Publishing, the leading local history publisher in the United States, is committed to making history accessible and meaningful through publishing books that celebrate and preserve the heritage of America's people and places.

Find more books like this at
www.arcadiapublishing.com

Search for your hometown history, your old stomping grounds, and even your favorite sports team.

Consistent with our mission to preserve history on a local level, this book was printed in South Carolina on American-made paper and manufactured entirely in the United States. Products carrying the accredited Forest Stewardship Council (FSC) label are printed on 100 percent FSC-certified paper.

MADE IN THE
USA